Manga Art
for Beginners

property of melissa D.M

Manga Art for Beginners

How to Create Your Own Manga Drawings

DANICA DAVIDSON
ILLUSTRATED BY MELANIE WESTIN

Skyhorse Publishing

Skyhorse Publishing books may be purchased in bulk at special discounts for sales promotion, corporate gifts, fund-raising, or educational purposes. Special editions can also be created to specifications. For details, contact the Special Sales Department, Skyhorse Publishing, 307 West 36th Street, 11th Floor, New York, NY 10018 or info@ skyhorsepublishing.com.

Skyhorse® and Skyhorse Publishing® are registered trademarks of Skyhorse Publishing, Inc.®, a Delaware corporation.

Visit our website at www.skyhorsepublishing.com.

10 9 8 7 6 5 4 3 2

Library of Congress Cataloging-in-Publication Data is available on file.

Cover design by Laura Klynstra
Cover illustration by Melanie Westin

ISBN: 978-1-5107-0004-8
Ebook ISBN: 978-1-5107-0006-2

Printed in the United States

Contents

Introduction

There are a lot of reasons to love manga—impressive story arcs, loveable characters, the ability to tell any kind of story you want. And then there's manga's art. This artistic style, which is distinctly Japanese, is a beautiful and expressive way to draw characters and scenes.

Maybe you fell in love with manga after first experiencing Japanese anime, like *Pokémon* or *Attack on Titan*, and this led you to the manga version. Or maybe you've always loved comic books, or you've been a big Nipponophile (a lover of Japan and Japanese culture). However you got here, there's a good chance your love of the medium got you to want to show your appreciation by creating your own manga. So, what next?

This book will show you the steps of drawing your own manga characters. It covers basics, like hands and eyes, then moves on to specific steps on how to draw common characters found in manga, such as ninjas, bishonen, and butlers. Characters are shown with different personalities and style.

The book also teaches you how to draw from different angles. You can mix and match characters here, too. For example, you can put the maid's tilted head on any body, not just the maid. It is also written with simple, accessible language so it's easy to understand. You don't have to take art classes and know art terms before approaching these pages.

Manga is about art, and it's also about having fun. Let's experience the beauty and uniqueness of manga together!

Getting Started

Odds are if you picked up this book, you're a manga fan. So how about creating your own manga characters and art, or perhaps even your own manga book? The first step is to get the right tools to start drawing.

Traditionally manga has been drawn on paper. You'll need a pencil to start out. Mechanical pencils are especially good for light, even lines. Later on you can ink the picture in. You can pick pens of different thicknesses, depending on your preference, but it's important that the ink dry fast. If you want to share online afterward, you can easily scan and upload it.

Drawing manga has often gone more digital lately. You can draw the entirety of your manga on your tablet or computer. You can use your mouse to draw on your computer. With tablets, you'd be using a stylus. Like drawing with a real pen or pencil, you can press harder or softer on your stylus for the intended thickness and darkness you want. Working digitally also makes it easier to erase—you don't have to worry about smudge marks from erasing pencil lines or messing up in ink. The downside is the usual downside with technology: it could break or need to be replaced. Ultimately, both ways of drawing have their strengths and weaknesses, so feel free to draw on paper or on a screen or both—whatever works best for you!

Face

The shape of the face can alter depending on the character. For instance, younger characters and female characters tend to have more round or oval faces. A grown man's face is more likely to be longer as opposed to oval. These aren't hard and fast rules. Here is a basic manga face to get you started.

1. Start with a basic circle.

2. Find the center and mark the bottom half. These will be your guidelines.

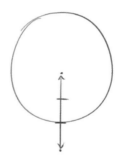

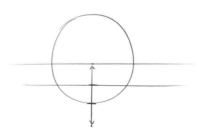

3. Put lines where you marked. This will help you know where things will go. For this face, put a dot below the circle that's the same amount of distance as the lines in the circle. Depending on how big you want to make the face, you can alter the spot of the bottom dot. If you want someone with a bigger chin, for instance, place the bottom dot farther away.

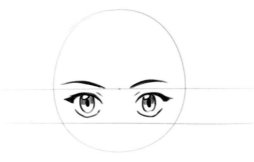

4. Now things will get a little more interesting. Work on eyes within the lines and put brows over the line above them.

5. Draw a chin down to your blue dot.

6. Draw in ears. Have the tops of the ears align with your eyes. Put in a mouth just below your original circle. A nose will go between the eyes, just underneath the lower blue line.

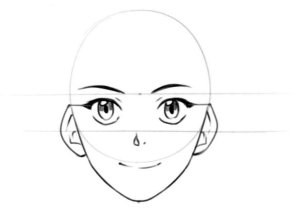

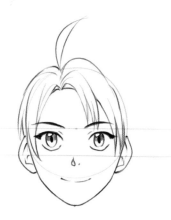

7. Now you can start adding hair. Begin with the top of the head.

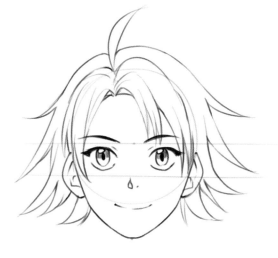

8. Add more hair for a more full look.

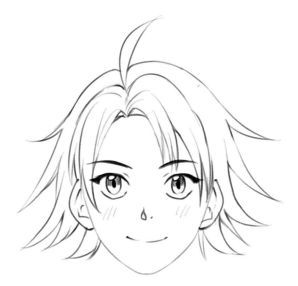

9. Erase the original blue marks. You can add a few lines under the eyes as blush marks. You now have a beautiful manga face looking back at you!

Eyes

Eyes in manga are known for being large and dewy, but the truth is manga eyes don't come in one form. Big eyes go with characters who are young, innocent, or female. Thinner, more realistic eyes tend to go with more mature or male characters. For instance, an adult female will probably have bigger eyes than an adult male, even though they're both mature. But if you have two adult males and want one to look more cute and friendly and the other to look more serious and austere, you'll give them bigger and smaller eyes, respectively.

1. First, draw this simple curve.

2. Next, we're going to put in a smaller curve for the bottom of the eye.

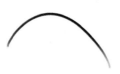

3. Now we put in an egg shape between the two curves. Looking good, right?

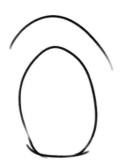

4. Color in the top curve.

5. We add a smaller egg shape to the top of the eye. This will end up being a reflection.

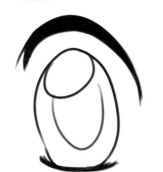 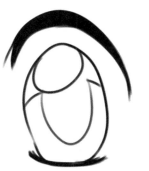 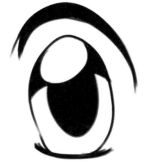

6. Next we put in the pupil. Still a pretty basic egg shape, and we want it below the last egg shape (the reflection) and to the middle of the eye. You can also darken the bottom curve.

7. Put lines just to the side of the pupil and below the reflection.

8. Color in the lines you just put in, plus the pupil.

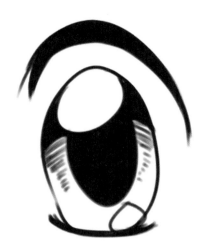

9. Add some dark lines to the sides of the pupil. Start out long and have the lines get shorter as you go down. This brings extra depth. Put another small reflection on the bottom right of the eye.

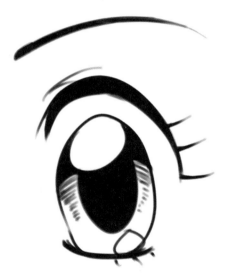

10. Put in the curve for the eyebrow. Start out thick and let it taper off by the end. Add some pretty lashes and then some crease lines to the left of the eye to give it some realness. Then sit back and admire your great work!

Manga eyes come in different styles, depending on the character and character type. Take a look at these.

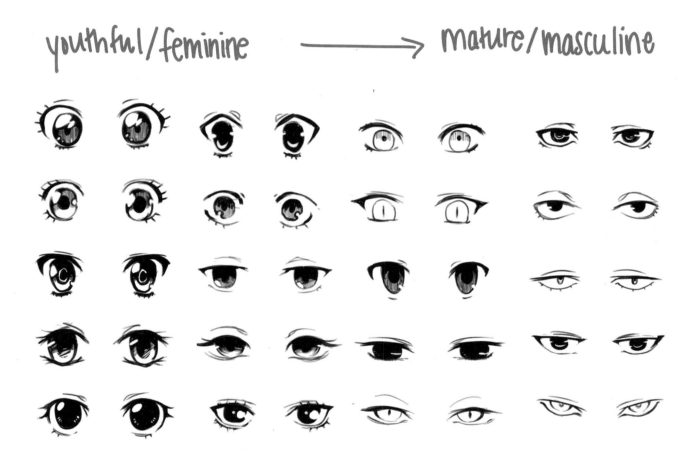

youthful/feminine ⟶ mature/masculine

Profile

Do you want to draw a face, but have it looking to the side instead of out front? This will also start with a circle, but then you'll be taking some different steps.

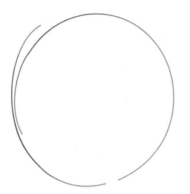

1. Draw a circle.

2. Next add a squarish end to the circle.

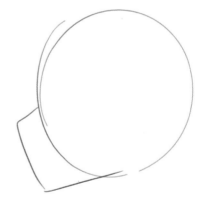

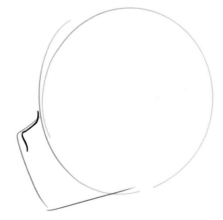

3. Use the square to help you draw the small curve of a nose.

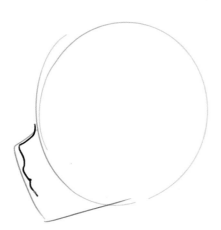

4. Indent slightly below the nose and form a mouth.

5. Draw another curve out to create the chin.
 The chin will touch the bottom of your
 square.

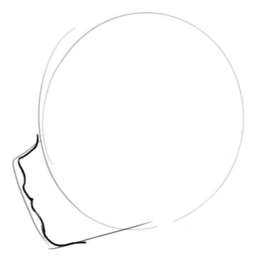

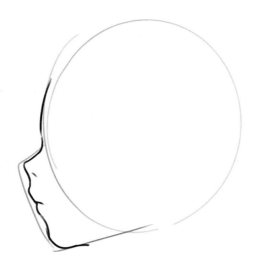

6. Draw some space above the circle for your
 forehead. Draw the lips and put a small mark
 for the nose.

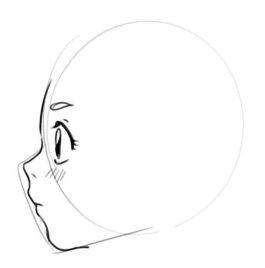

7. Add an eye. The pupil will have more of an oval shape because of the angle. Remember the reflection on the eye and the eyebrow above.

8. Elongate the jaw and add an ear. Curve the chin down into a throat.

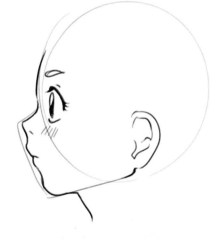

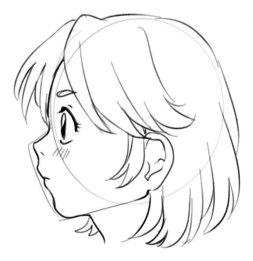

9. Add hair and have it curve and curl around the face. Erase the blue lines when you're done.

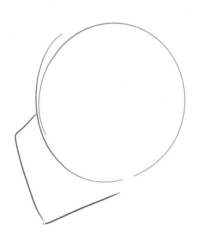

1. Drawing a more masculine face in profile takes mostly the same steps. Start with a circle and square, but make your square bigger.

2. See how the steps are the same but the proportions are different.

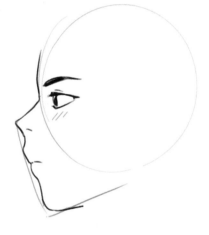

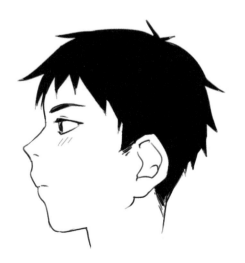

3. Finish with ear, hair, and neck.

Faces From Different Angles

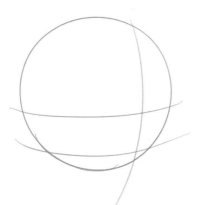

1. Draw a circle, plus some lines to guide you.

2. Use the lines as a guide for the placement and size of the eyes, nose, and brows.

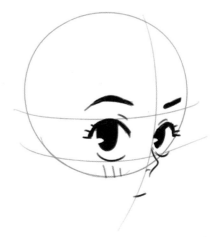

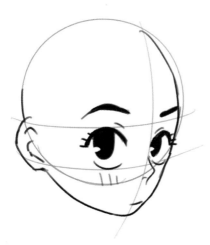

3. The forehead will go inside the circle. The chin, jaw, and ear will go outside.

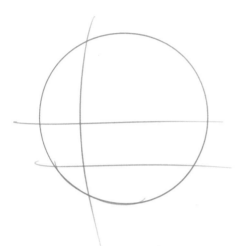

1. Flip the lines the other way on the circle.

2. Add in nose, eyes, brows, and mouth.

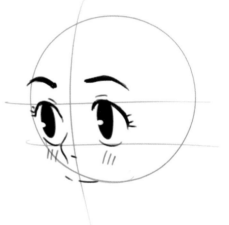

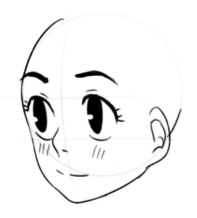

3. Draw in chin, jaw, and head.

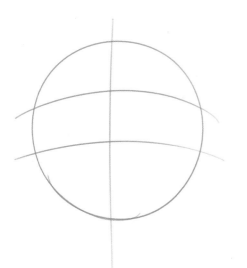

1. If you want to draw a face that's toward the audience but looking up, draw a circle and put your lines to the middle and up.

2. As before, use the lines in your circle to guide where you put your eyes, nose, mouth, and brows.

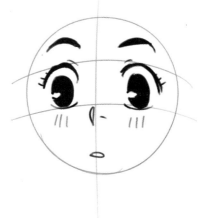

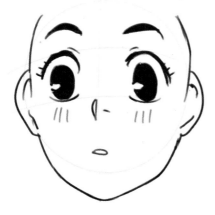

3. Finish off the face.

Different Expressions

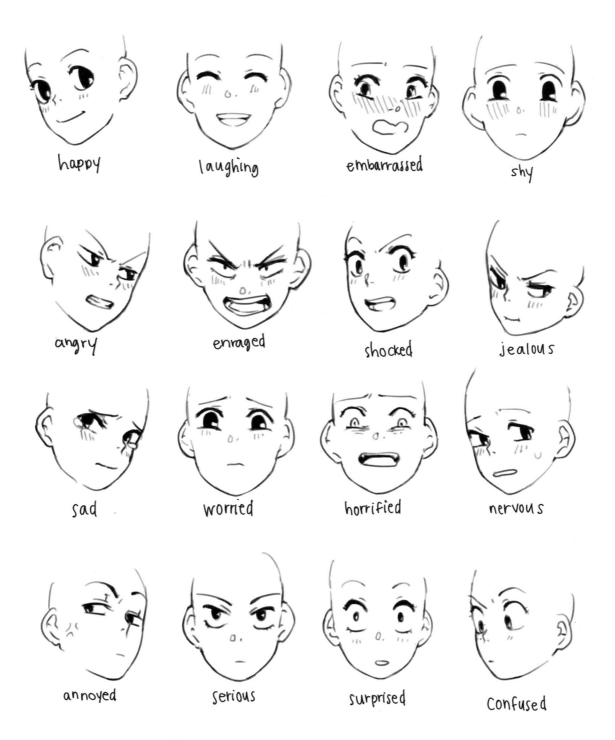

happy laughing embarrassed shy

angry enraged shocked jealous

sad worried horrified nervous

annoyed serious surprised confused

Manga Expressions

Some expressions are pretty specific to manga. A few lines make blank, unamused eyes. A giant sweatdrop is for someone nervous. Disgust gets darkened lines. Swirly-eyed has just seen something crazy. Fangs can pop on a character for a moment to symbolize evil—not that they're a literal vampire. Screaming is shown through wide mouths. Hearts for eyes exemplify love. Crying (especially if you want to show it comically) can be two giant streams of liquid. When someone finds someone else attractive, they might blush. And the nosebleed? In manga, the blood might rush to their face so hard it comes out their nose. A bloody nose is a sign of attraction.

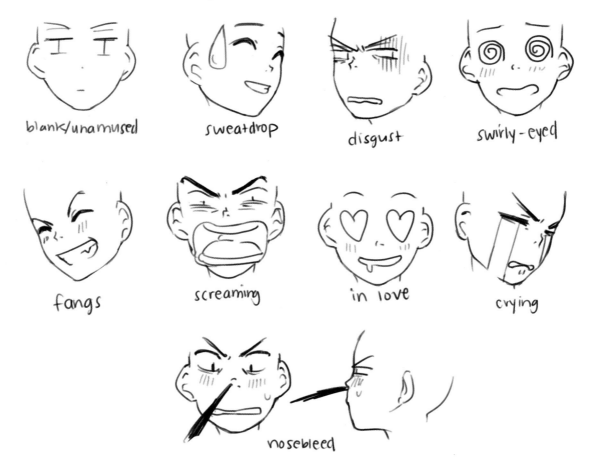

blank/unamused sweatdrop disgust swirly-eyed

fangs screaming in love crying

nosebleed

Basic Body Shapes

Male Body

Male bodies will have larger shoulders than female bodies, and longer legs than people have in real life. Drawing with lines and circles can help you figure out your proportions, like knowing where joints go.

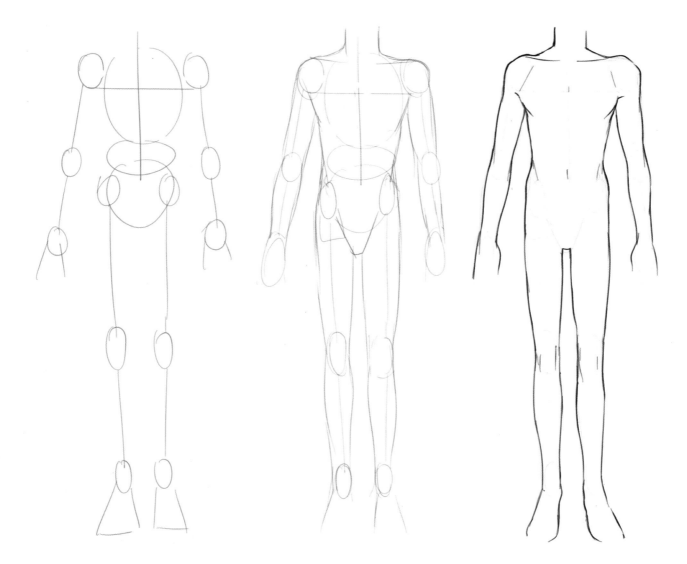

Female Body

A female body will be curvier. It will have smaller shoulders than a male body, but it will still have legs that are longer than in real life.

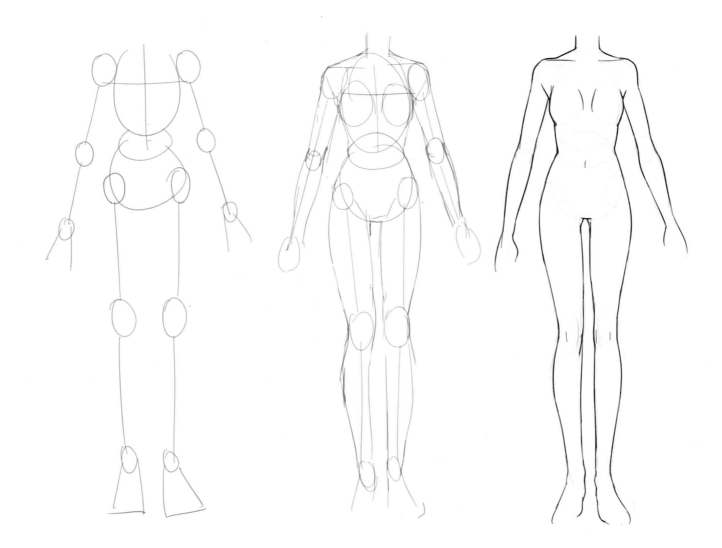

Body Proportions

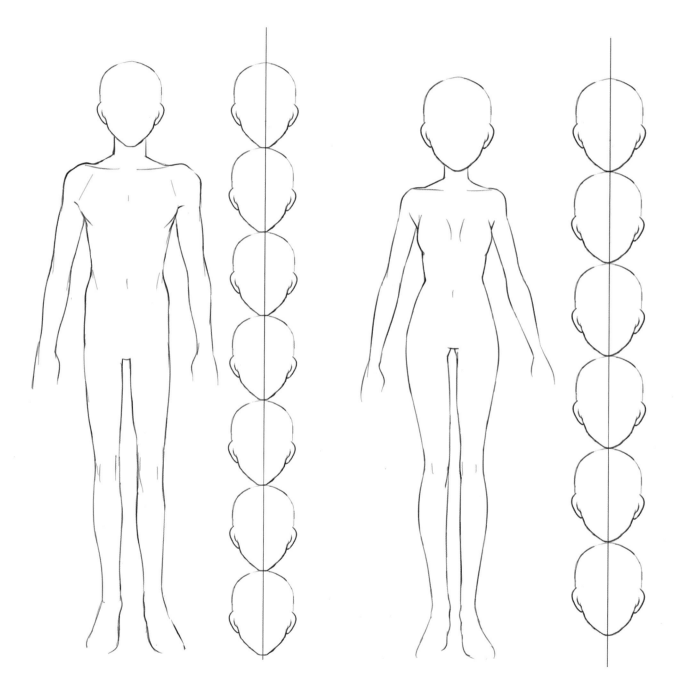

Notice that with the male body on the left, he equals out to seven heads. The woman on the right equals out to six heads. In reality, people are proportionally about 7.5 heads.

Women's Proportions

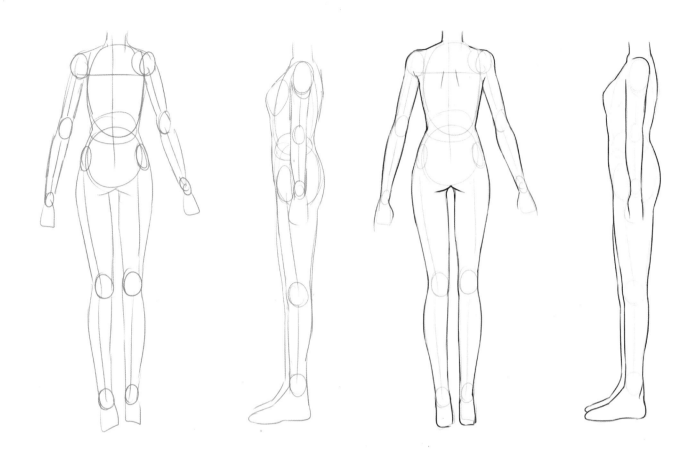

Men's Proportions

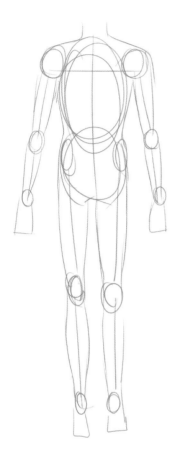
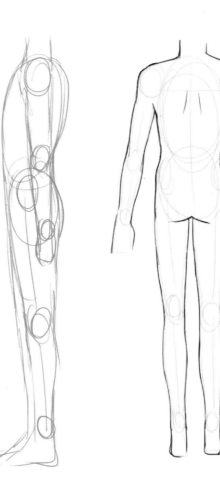
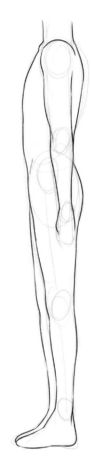

Hands

1. Start with a rectangle and draw a line in the middle.

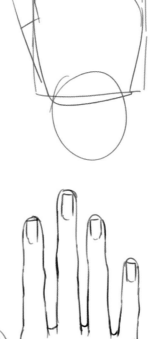

2. Use the rectangle to draw in a blocky, basic hand shape. Fingers will be about the same length as the palm.

3. Use the blocks to get more specific in shape.

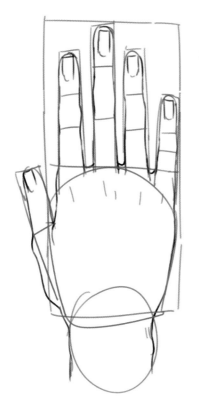

4. Erase the original lines.

Fist

1. Making a fist will be similar to making a hand. Start with a tilted square.

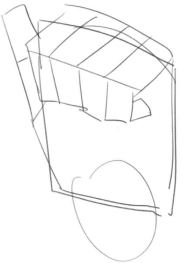

2. Use the square as an outline for a basic, blocky hand.

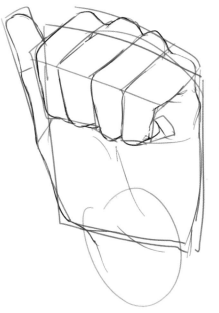

3. Use the block hand as a guide for more details.

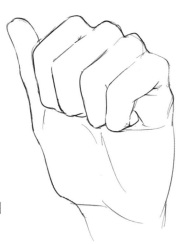

4. Erase the original lines.

A lot of emotions can be expressed with hands. Use the basic square and rectangle technique for hands like these.

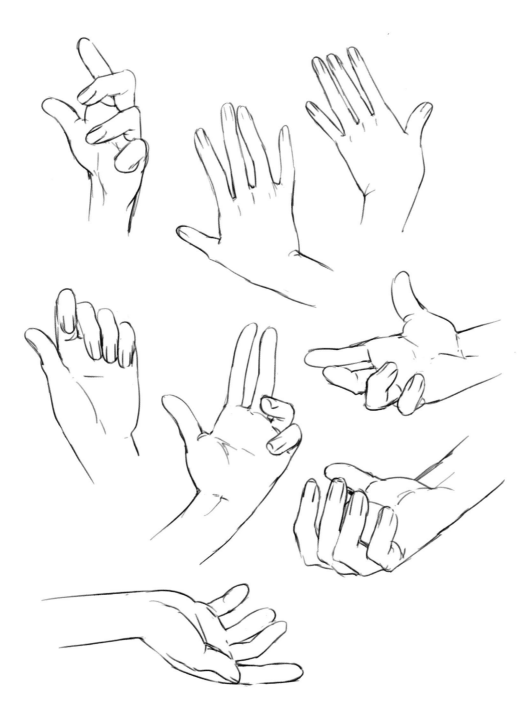

Feet

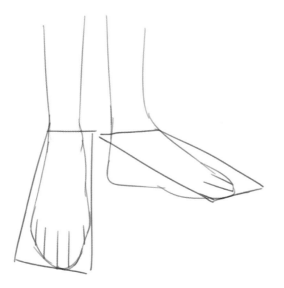

1. Like hands, you can use rectangles to draw feet. Start with the basics.

2. Put in more detail. You won't be able to see all the toes on the right foot because of the angle. Toenails will vary in size.

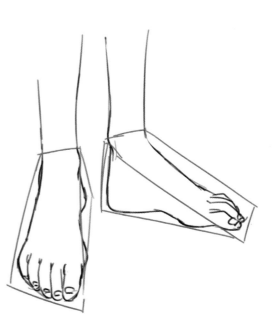

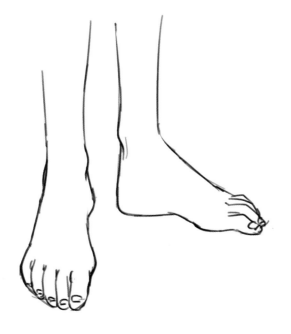

3. Erase original lines and finish.

You can use this technique for feet at different angles.

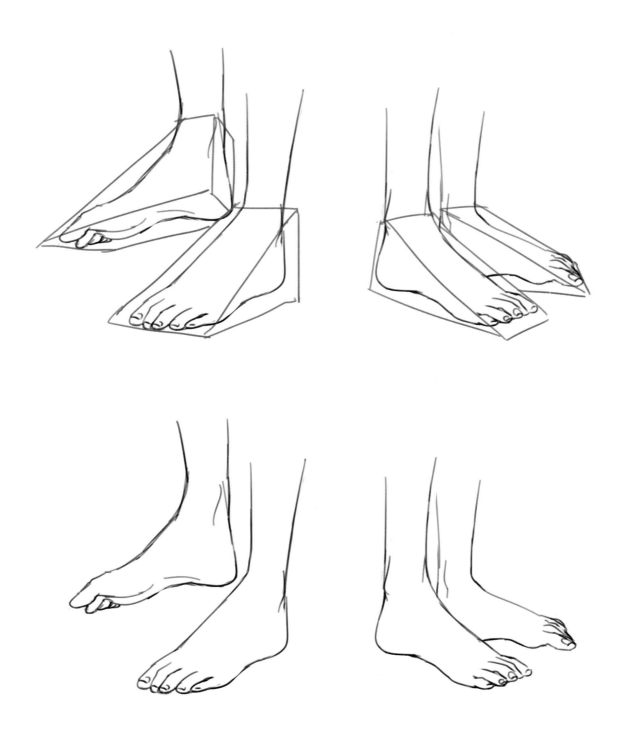

Hair

Hair in manga can be very simple or very extravagant. In a world on paper where there is no gravity, hair is here to do your bidding! Here are some ideas for manga hair styles. Watch where the hair flows away from the head. Hair doesn't fall flat but has volume. If someone is moving, their hair will move, too.

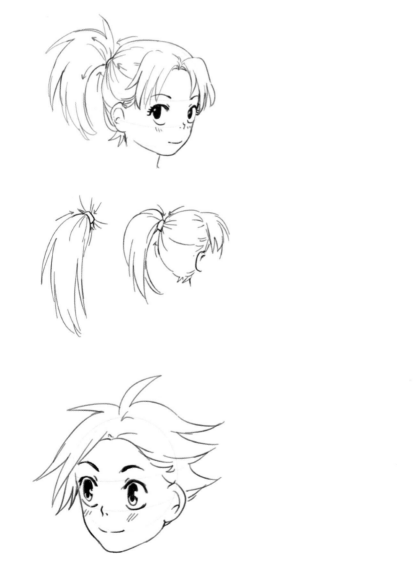

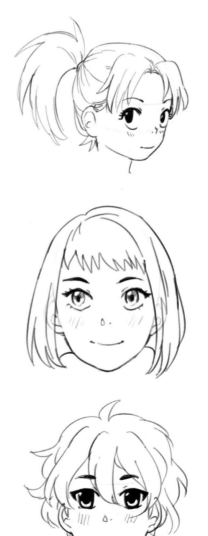

For braids, start with two curved lines across from each other. Keep adding more of these curves so they make a chain. Then go back and fill in the inside with more detail.

Notice how the hair moves from the scalp.

You can also keep hair simple without all the detail in the tresses.

Teen Boy

Now that you've gotten basics, let's move on to character types found in manga. Many manga star teenage protagonists, so here is how to draw a teenage boy.

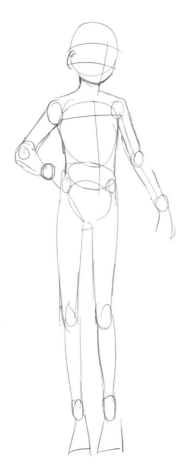

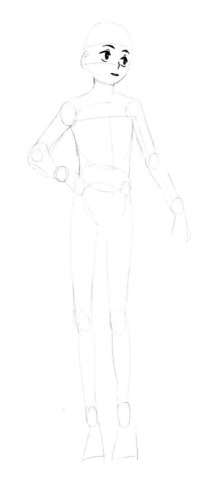

1. You want to start with the basic outline of the body. This will guide you with your proportions.

2. From there you can start to fill out the face. Because he's young, he'll probably have big eyes.

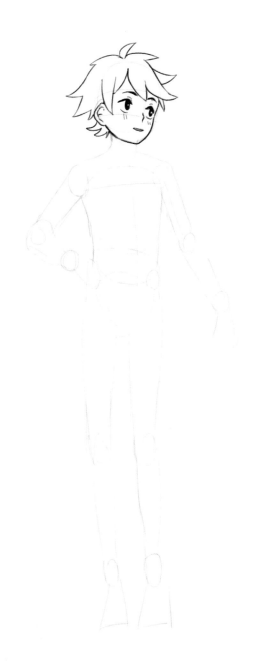

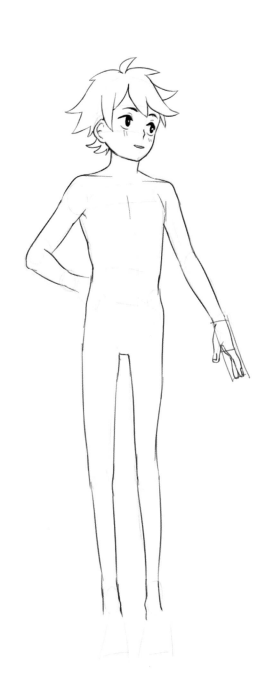

3. Fill out the head and spiky hair.

4. Outline the body and draw in the hand (using the rectangle technique).

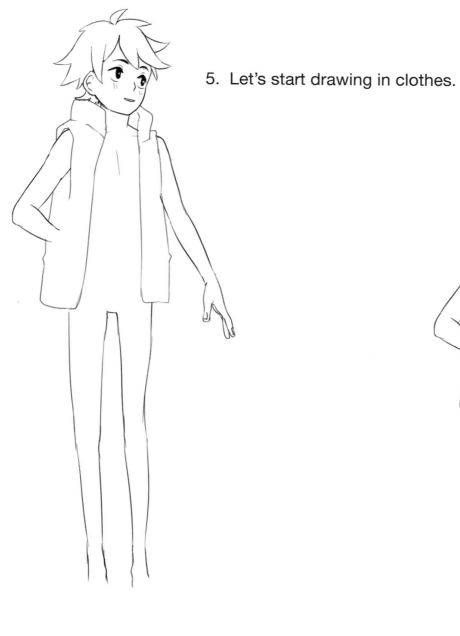

5. Let's start drawing in clothes.

6. Add pockets to his vest.

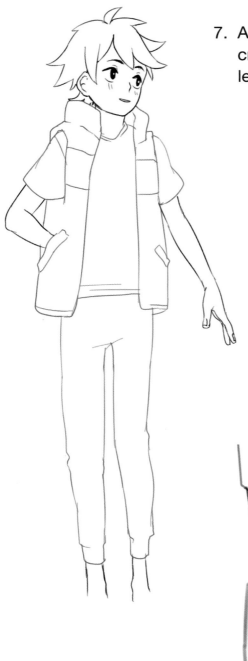

7. Add a shirt. The sleeves will have little creases and the pants will be thicker than his legs.

8. For his shoes, start with rectangles over his feet.

9. Give some depth to the shoes.

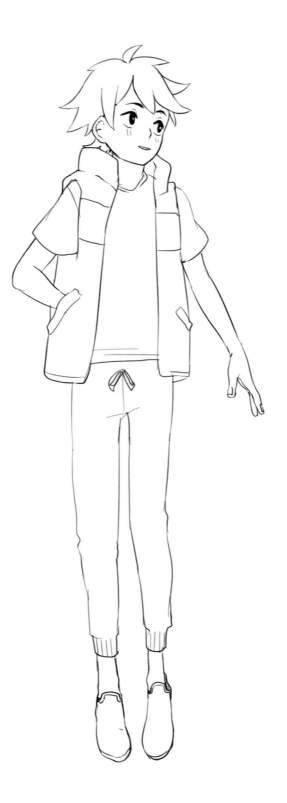

Teen Girl

Now it's time to take a look at how teen girls are drawn. You might notice that oftentimes in manga female characters wear skirts or dresses as opposed to pants. This teen girl is wearing a skirt, but feel free to put her in whatever style of clothing you like.

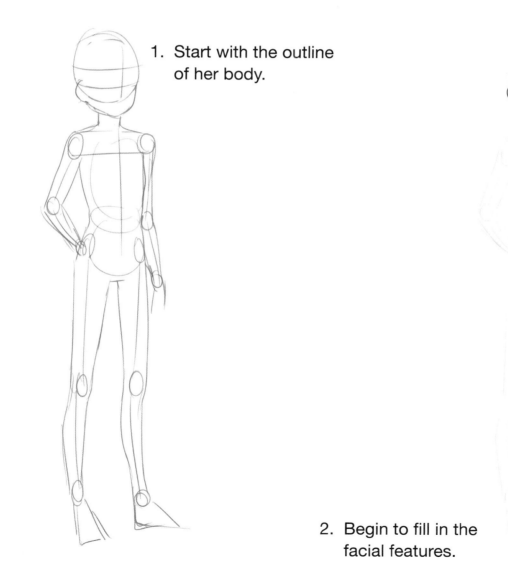

1. Start with the outline of her body.

2. Begin to fill in the facial features.

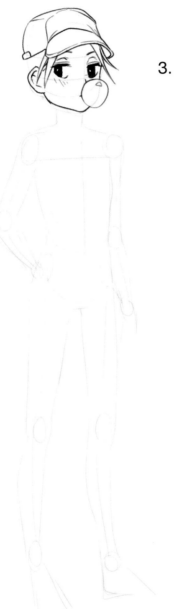

3. Draw in the hat.

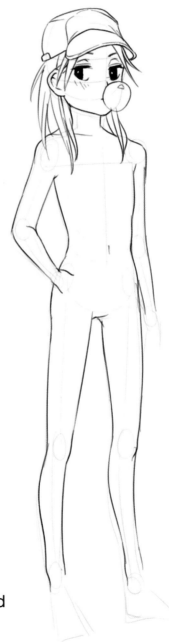

4. Outline the body and
 add the hair.

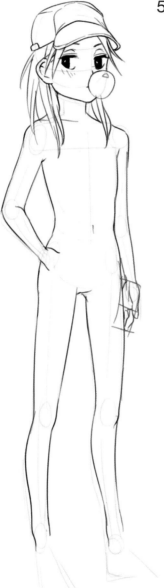

5. Use a rectangle to make the hand.

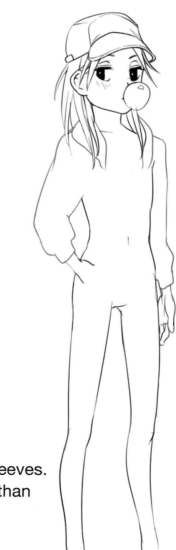

6. Begin to fill out her sleeves.
 These will be thicker than
 her arms.

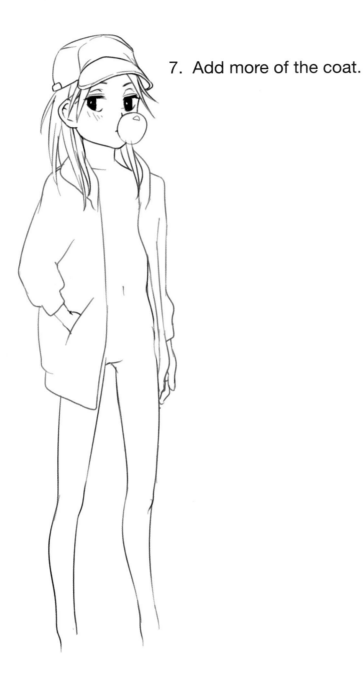

7. Add more of the coat.

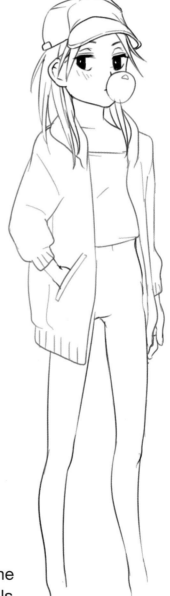

8. Give the coat some
 creases and details.
 Add a shirt.

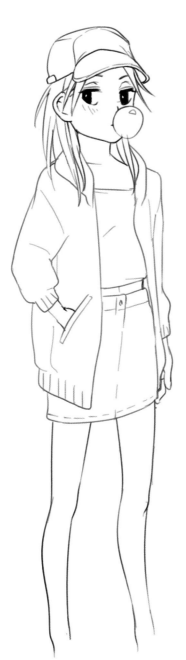

9. Give her a skirt.

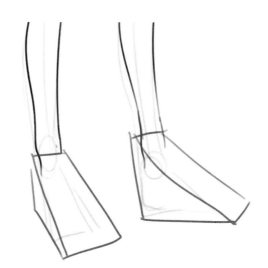

10. Since she's at an angle, her feet will be too. Use three-dimensional triangles to get the shape of her feet.

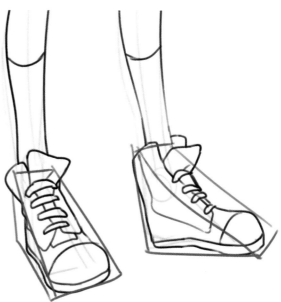

11. Use these shapes to draw in the shoes.

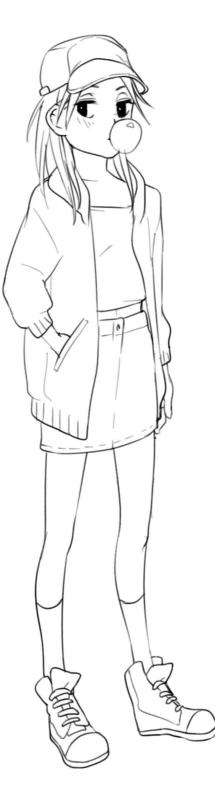

Schoolgirl

In Japan, kids wear uniforms to school, though different schools have different uniforms. You can make alterations to the uniform in your drawings, but here is a generic image that can easily be tweaked the way you want it. She has a cute ribbon in her hair, so feel free to use that or take it out. This could also be a guide to drawing other characters with ribbons.

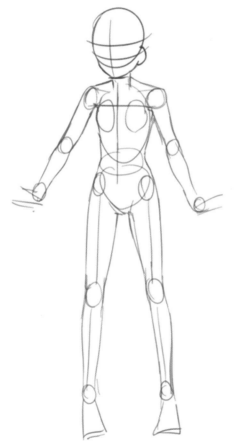

1. Start with the proportions.

2. Begin with her face. A schoolgirl will have big, expressive eyes.

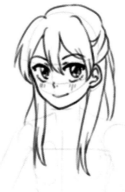

3. Next draw the front of her hair. Have it flowing out from the scalp.

4. Fill out more of her hair from the back. Some of it will fall back behind her shoulders and not be seen. The hair that she has tied around the back of her head should start above the ears.

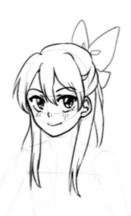

5. Add a ribbon to her hair.

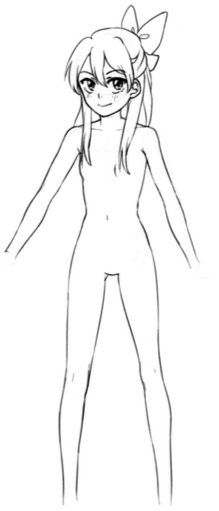

6. Outline her basic body shape. She will be less curvy than an adult woman.

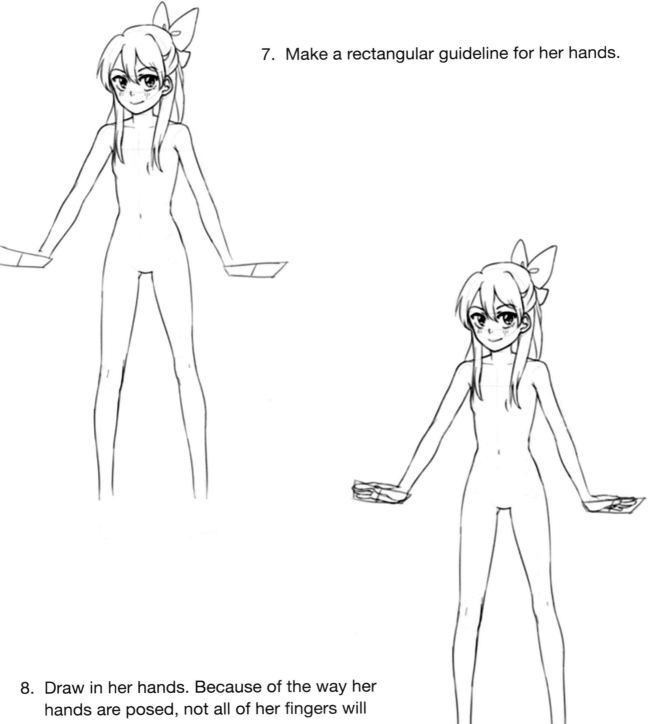

7. Make a rectangular guideline for her hands.

8. Draw in her hands. Because of the way her hands are posed, not all of her fingers will be fully seen.

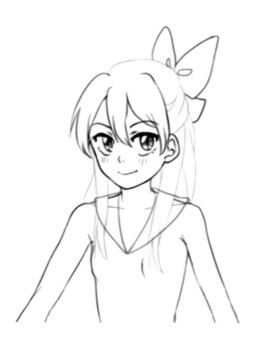

9. Start with a basic collar.

10. Add details to the collar.

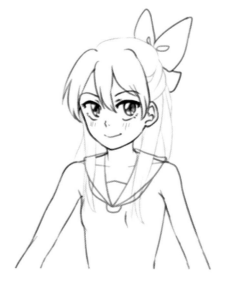

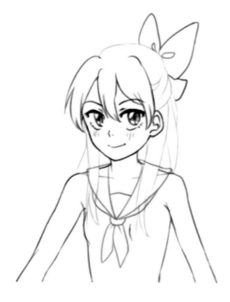

11. Add a bow. Sailor schoolgirl uniforms can be common in manga.

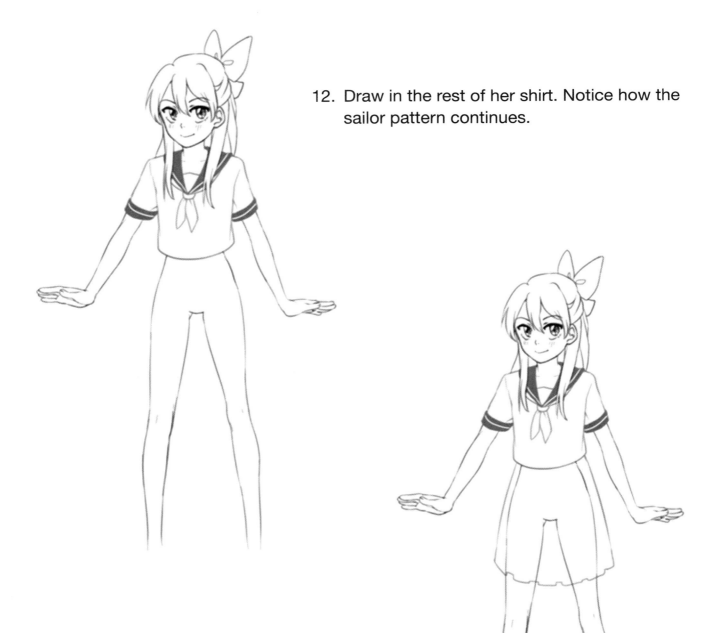

12. Draw in the rest of her shirt. Notice how the sailor pattern continues.

13. Draw the basic outline of the skirt. The skirt should have jagged edges and not be a smooth curve.

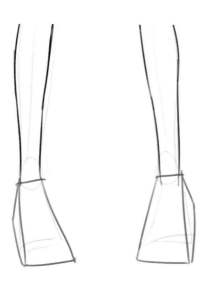

14. Outline the area for her feet.

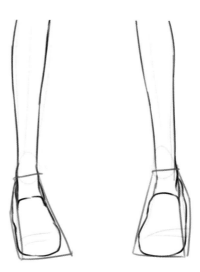

15. Draw in basic shoes.

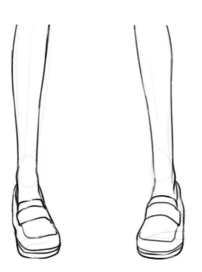

16. Finish the shoes. Note how the two lines above the front give it depth.

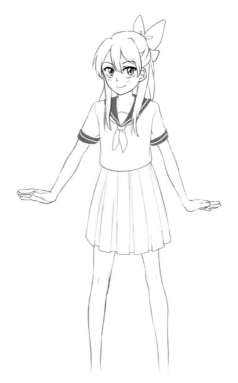

17. Give the skirt creases to make it look real. Most but not all of the creases will go all the way up to her waist.

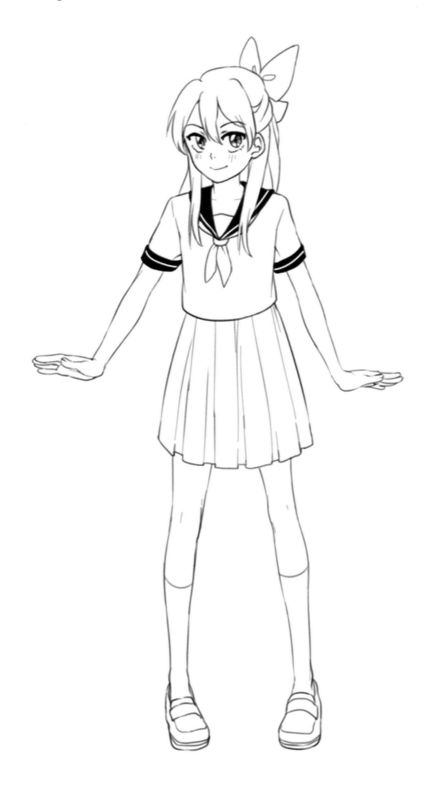

Schoolboy

Like schoolgirls, schoolboys are common in manga. Again, this is a generic look that can be tweaked if you'd like to draw something in particular. This is a fairly simple outfit, and you can see he's holding a bag over his shoulder.

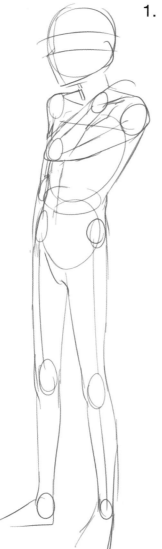

1. Do a proportional outline. Even at this angle the shoulders will still be the same distance apart.

2. Start to fill in the face. Because of the angle, one eye will be smaller and partially covered by the nose.

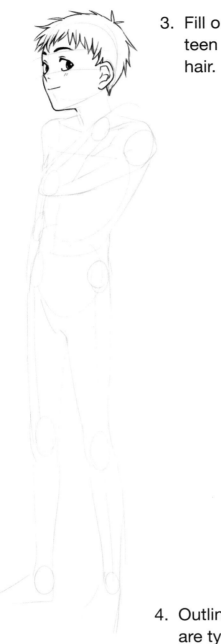

3. Fill out the head. Oftentimes teen boys in manga have spiky hair.

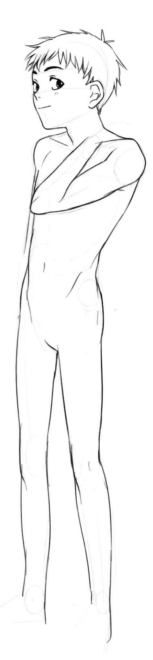

4. Outline the body. Teen boys are typically drawn lanky and without the solidness of older male characters.

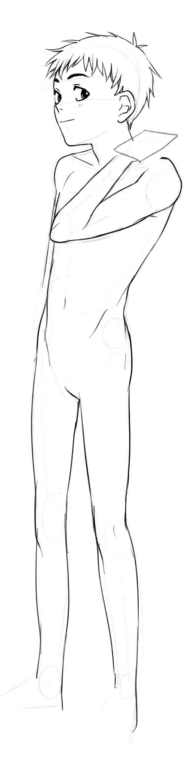

5. Make a rectangle to guide you with the hand.

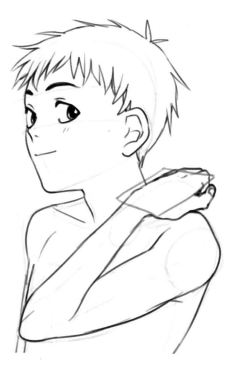

6. Because he's holding the strap of a bag, his hand will be curved back. We're only going to see two fingers.

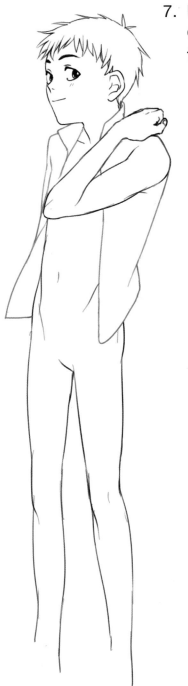

7. Draw in the collar and basic outline of his jacket. One part of the collar will be flipped to the side and the other will stand up straight.

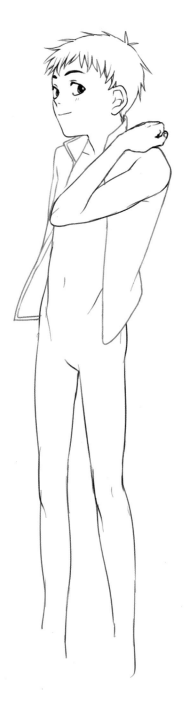

8. Outline the jacket.

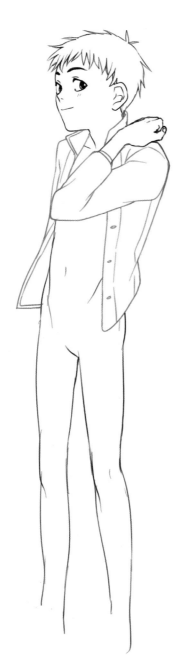

9. Give him sleeves and buttonholes.

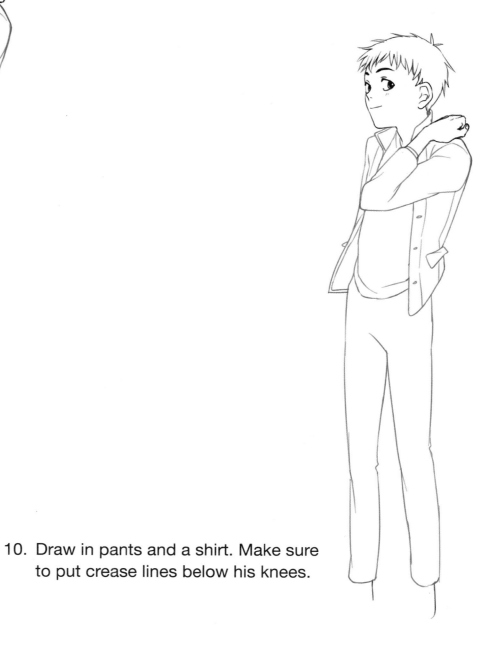

10. Draw in pants and a shirt. Make sure
 to put crease lines below his knees.

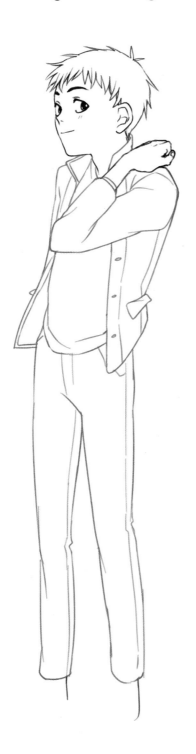

11. His pants will need to be lined for the seams.

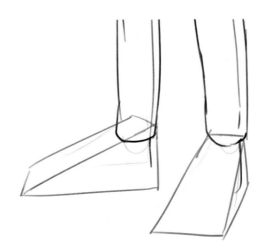

12. Outline his shoes.

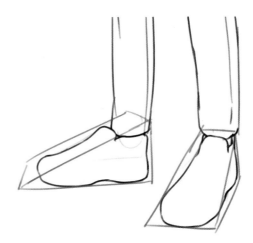

13. Draw the shoe shape in. Loafers work well for this character and are a simple design.

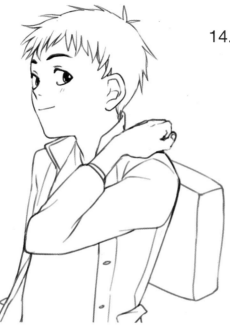

14. For his bag, begin with just the basic shape of it.

15. Now you can add more details, like the zipper and lines.

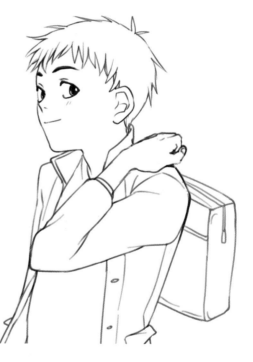

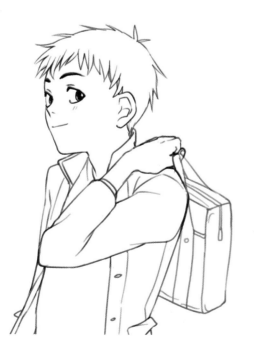

16. Finish the lines. Add a strap for him to hold. You will loop the strap over his thumb.

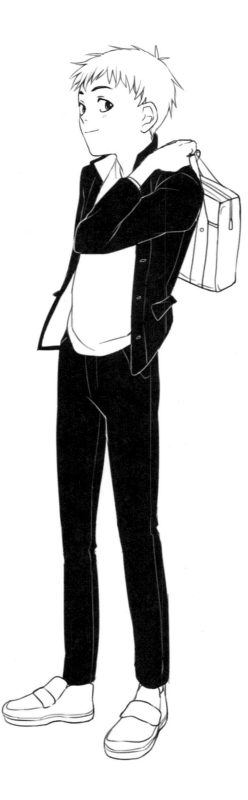

Little Girl

If you're writing manga about younger characters, you'll need to know how to draw children. We will start with a young girl with pigtails and a cute teddy bear.

1. Start with the outline. Her proportions will be smaller than an adult.

2. A little girl will have very big eyes. A couple lashes and blush marks really bring out the effect.

3. Bring out her face and the front of her hair.

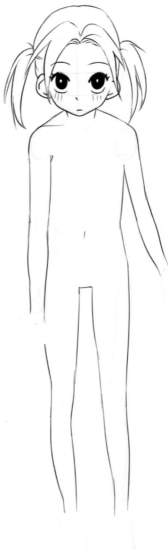

4. Complete her hair. Many
little girls in manga have
pigtails. Outline her body.

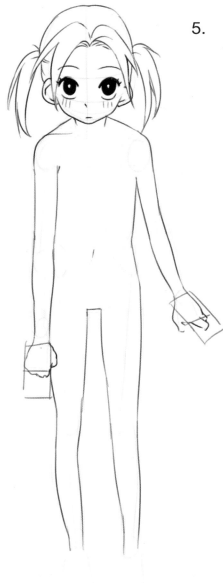

5. Work on her hands. She's going to be holding a teddy bear, so one hand will have to be positioned accordingly. Her other hand will be clutched to hold her dress. Notice how the hand that will clutch her dress just needs a few bumps for knuckles.

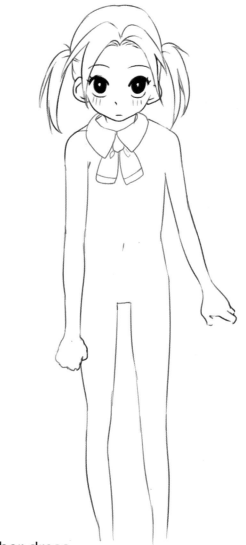

6. Draw in the collar for her dress.

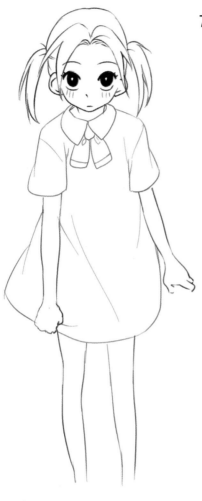

7. Draw in her dress. Remember to give it creases.

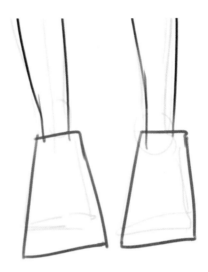

8. Her feet are facing straight toward you. Outline the position for them.

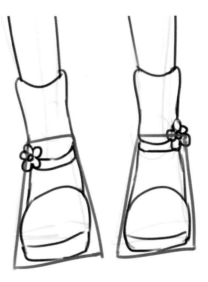

9. Draw in her shoes. The little flowers give it a nice touch.

10. Now let's work on her teddy bear. Start with a circle for the head.

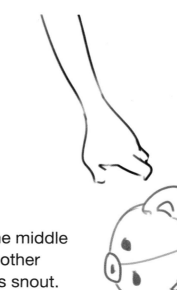

11. Draw a line down the middle of Teddy's head. Another circle will work as its snout. The ears will be kind of like half circles.

12. An oval with another smaller oval will work for its body.

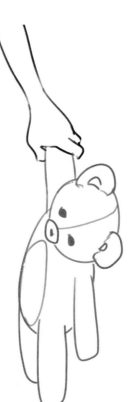

13. Add in the teddy's arms. One will disappear into the little girl's hand.

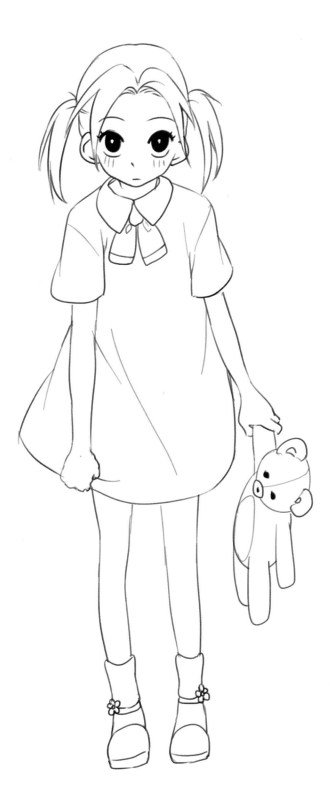

Little Boy

Here's a preadolescent boy in a standing position. You will notice that unlike the shoulder exaggeration of older males, his shoulders look more natural. Another tip: It's also common in manga for little boys to be drawn wearing shorts, though this doesn't have to be the case.

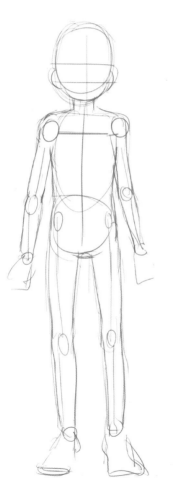

1. Begin with the outline to help with your proportions.

2. Like little girls, little boys will have big eyes. Unlike little girls, he doesn't need eyelashes, unless you want to give him some.

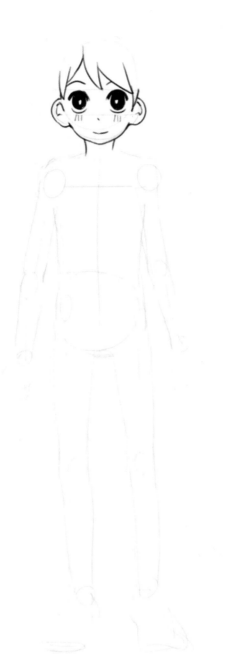

3. Draw in a roundish, cute face. Start on the hair.

4. Finish the hair. Remember to include tufts under his ears to give it a more full look.

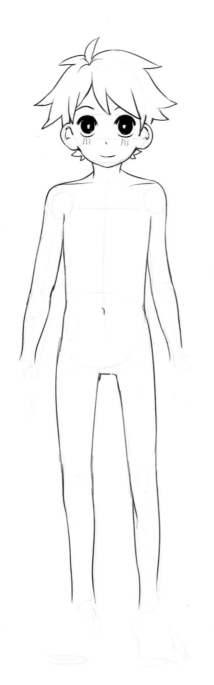

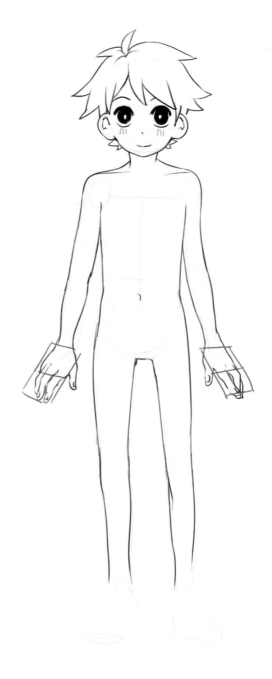

5. Outline the body.

6. Use your rectangular guidelines to draw in his hands. Even though he's smaller, his palms will still be the same length as his fingers.

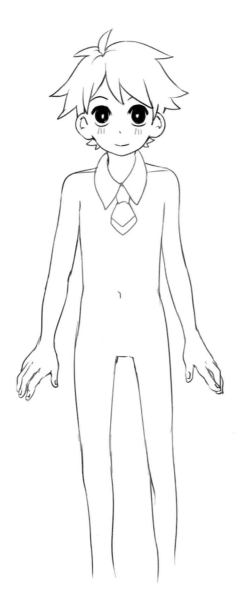

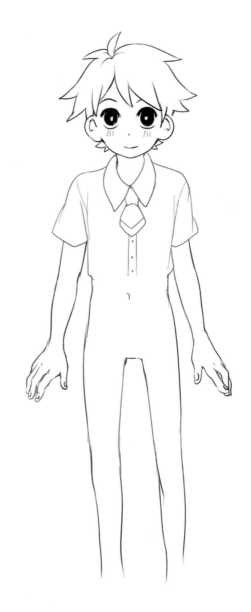

7. Draw in his collar and tie.

8. Continue with his shirt.
 Include buttons and creases.

9. Put in the basic outline of his shorts.

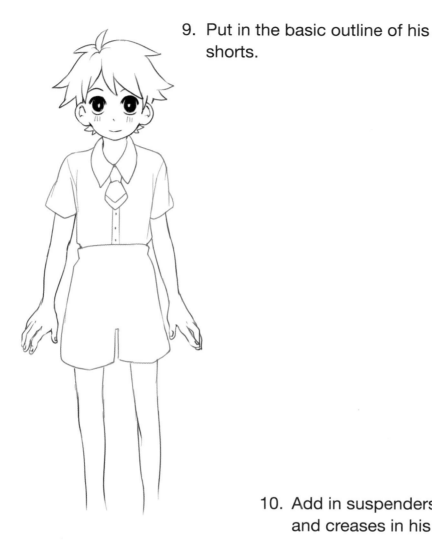

10. Add in suspenders and lines and creases in his shorts.

11. Draw your guidelines for shoes.

12. Draw in sneakers.

Woman

Adult women tend to be drawn curvier than teen girls. You'll notice she still has fairly large eyes, though not as large as younger characters, typically.

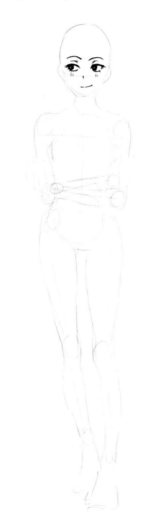

1. Draw in her proportions. She will be longer limbed than younger characters.

2. Draw in the eyes. The way she's looking to the side and the half-smile give her a look of amusement.

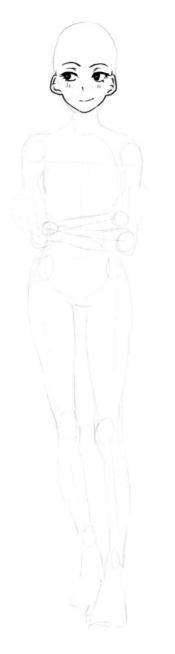

3. Draw the basic shape of her face.

4. Start with the front of her hair.

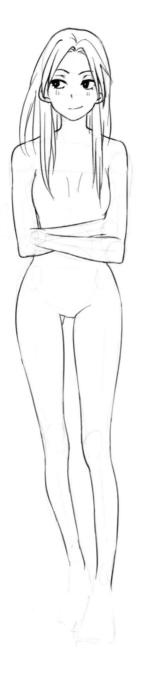

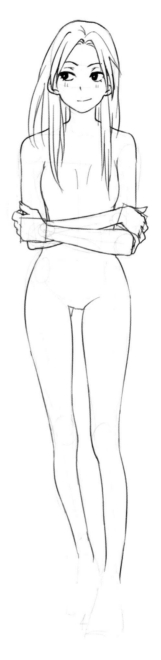

5. Finish the hair. Outline the body.

6. Draw in the hands. Notice how her fingers curl around her arms.

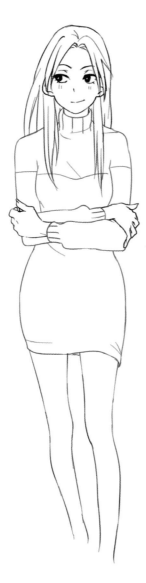

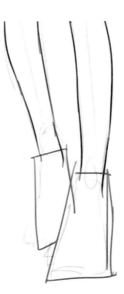

8. Outline for the shoes.

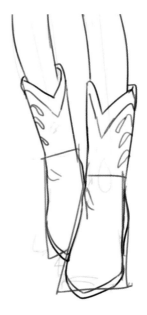

7. Draw in her dress. This will fit tightly around her body, though the sleeves are a little thicker than her arms.

9. Since she's wearing boots, these will go up higher than her feet. But you're still keeping with the same, basic shape.

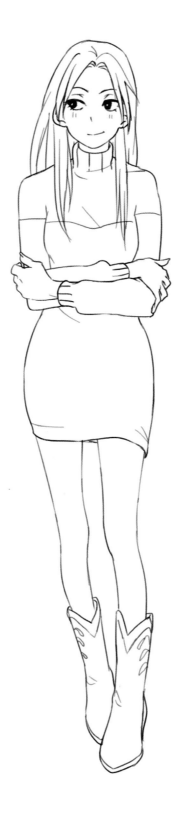

Man

Adult men aren't a whole lot different from teenage boys, but they tend to be drawn with wider shoulders and broader bodies. Their eyes are smaller, more like real eyes than the big round eyes manga is infamous for.

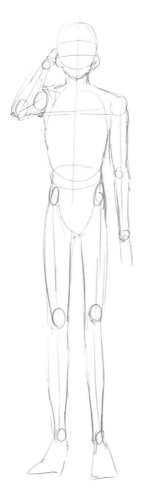 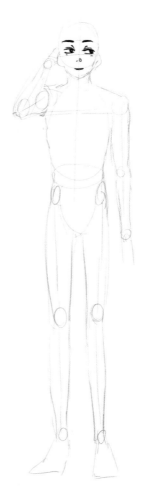

1. Start with the proportions. Remember long legs and wide shoulders.

2. Begin with the face. Typically adult male characters have smaller eyes than other characters.

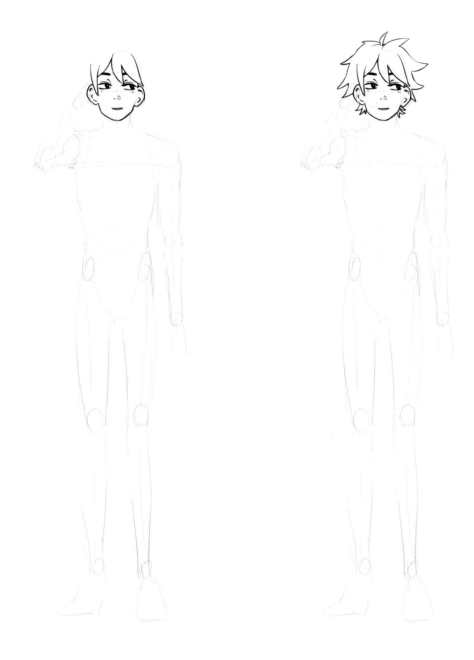

3. Draw in the face. Start on his hair.

4. Finish his hair in the back. Give him tufts of hair with a little feather on the top of his head.

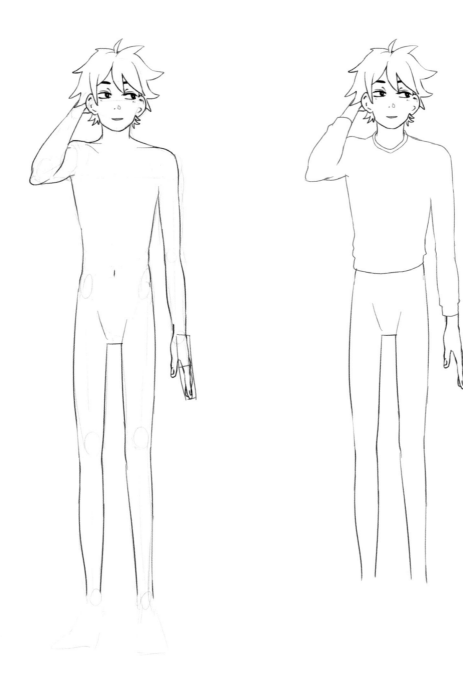

5. Outline the body. Draw in
 the hand. Because his hand
 is facing to the side, we
 won't see all of his fingers.

6. Draw in his shirt.

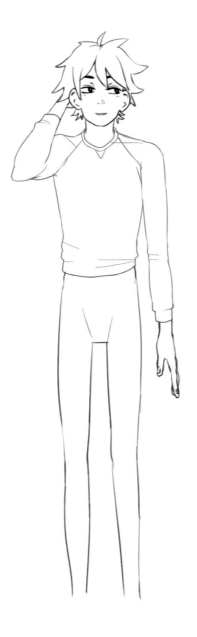

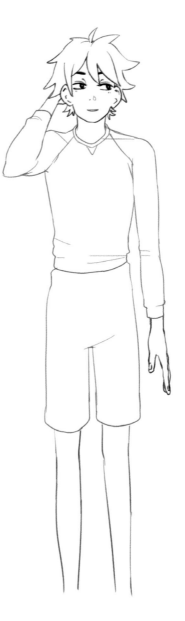

7. Add details and creases to the shirt.

8. Draw in the outline of his shorts. The shorts will be thicker than his legs.

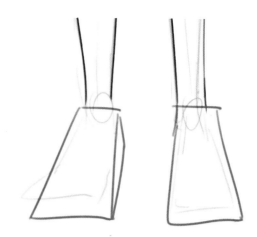

10. Make an outline for his feet.

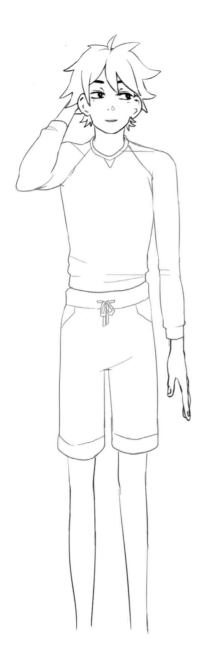

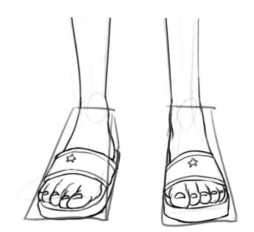

9. Finish his shorts. Include a tie. The tie will be two loops with two strings under it.

11. Draw in his sandals. Pay special attention the angles of his toes to get them just right.

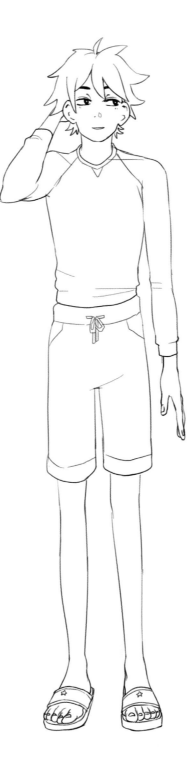

Baby

Everyone starts as a baby, but there's a big reason why we didn't put the baby up front for character drawings: babies are drawn differently than older people. They're still little and roly-poly, so you're going to want a different look here.

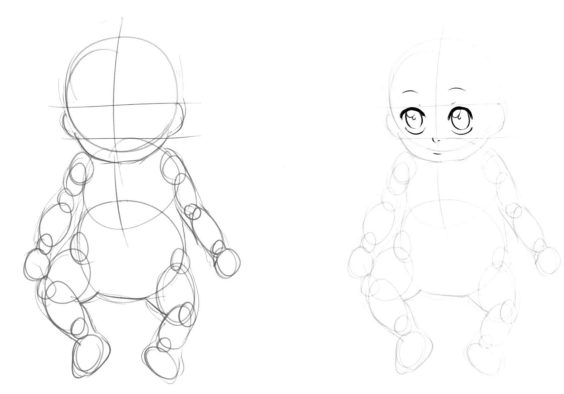

1. Outline the baby. The baby will have a large head and a rounded body.

2. Draw in eyes. In general, the younger the character, the bigger the eyes.

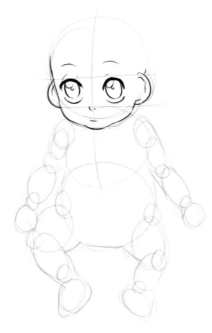

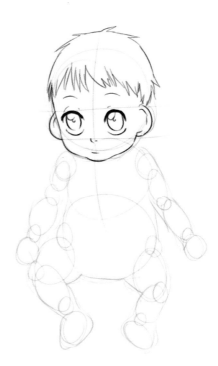

3. Outline the rounded face.

4. Draw in short hair. Babies usually don't have very fancy hairstyles.

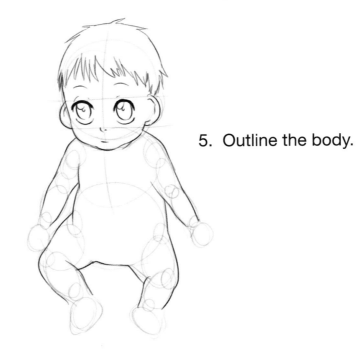

5. Outline the body.

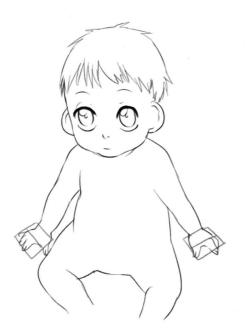

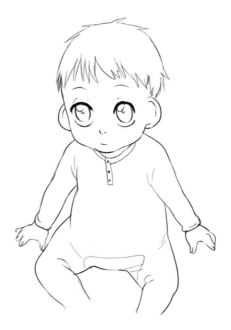

6. Draw in the hands. Because the hands are so little, you'll use a square shape instead of a rectangle.

7. Draw in the baby's clothes.

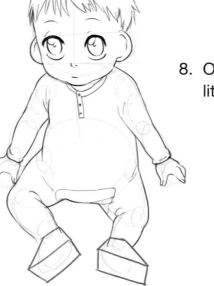

8. Outline and draw in the little feet.

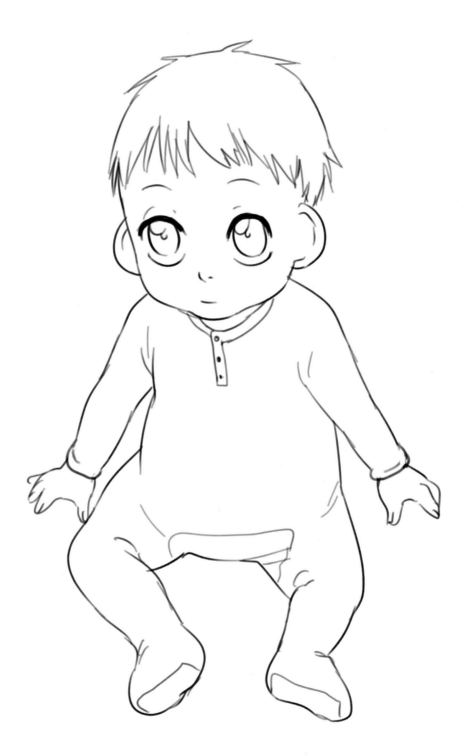

Shrine Maiden

The shrine maiden, or *miko*, is an image particular to Japan. Shrine maidens perform sacred rituals in Shintoism, though in manga they often take on secondary jobs . . . like fighting demons, maybe? You can change how the maiden looks, but her *miko* clothing will be the same. She'll be wearing a pair of *hakama*, which are a loose style of pleated pants. The *hakama* will be red. The *haori*, or jacket she'll wear, will be white.

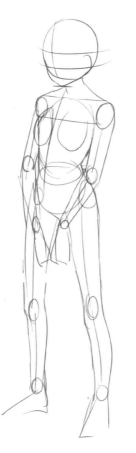

1. Draw an outline for proportions. Her arms will curve in so that her hands are almost touching.

2. Draw in the eyes and start on the face. Even though she's at a different angle, you'll want to use the same guidelines as in the beginning to work on her face.

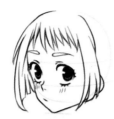

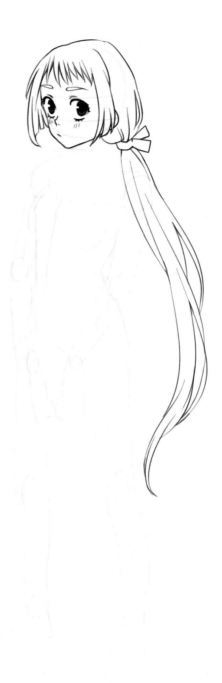

3. Draw in the front of her hair. The hair should get a little longer toward the front because of the way her head is dipped.

4. Draw the long hair down her back. Put some flow into it.

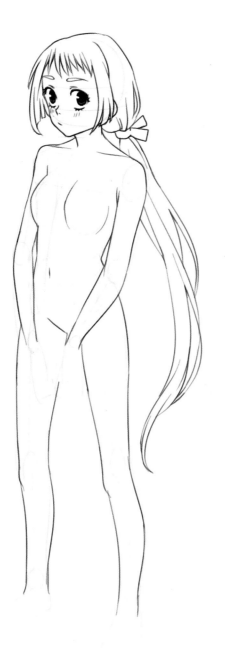

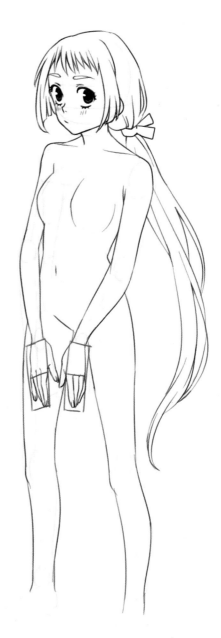

5. Outline her body.

6. Use rectangles to draw in her hands.

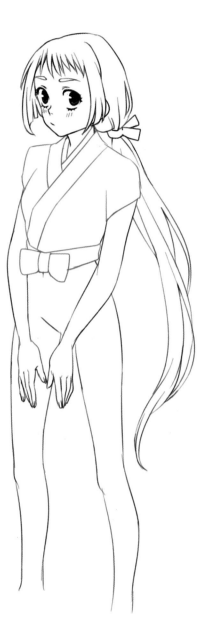

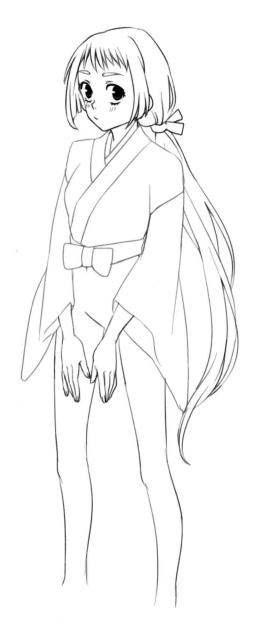

7. Begin on her clothing. *Haori* are worn wrapped left over right on the chest.

8. Add the long sleeves.

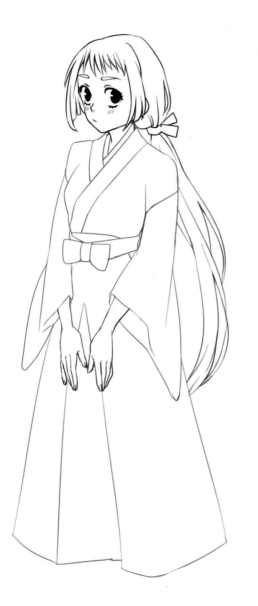

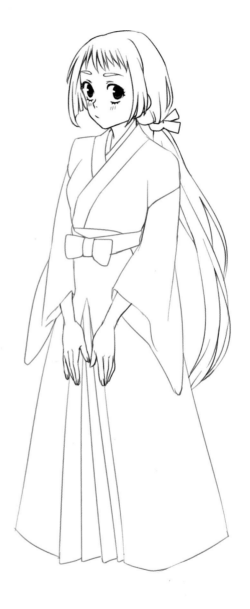

9. Draw in the length of her garments. What she's wearing on the bottom is the *hakama*.

10. Add pleats to her *hakama*.

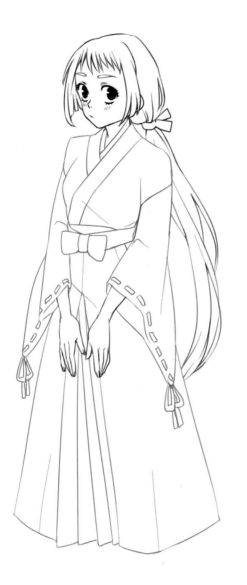

12. Outline the feet.

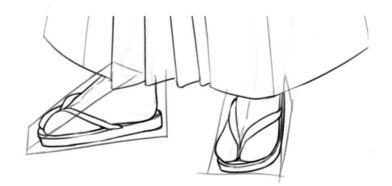

13. Draw in her sandals. This type of thonged sandal is called *zori*. She's wearing socks underneath, so you don't have to worry about her toes. This kind of sock is called *tabi*.

11. Finish off the sleeves with threading and ribbons.

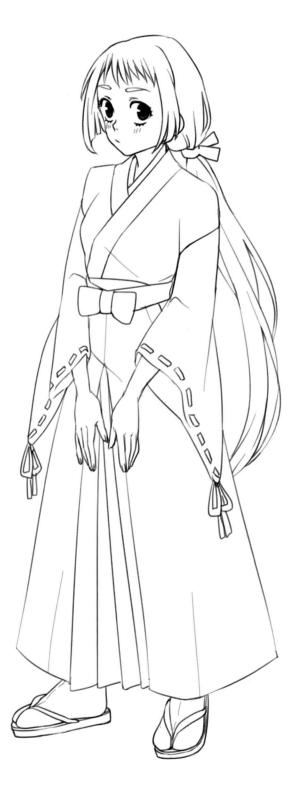

Magical Girl

The magical girl is a common theme in Japanese entertainment. *Sailor Moon* is the most famous example of a magical girl manga character. She really can look however you want, as long as she's magical and as long as she's a girl. But some trademarks tend to be common, like long (often pigtailed) hair and the fact she's usually accompanied by some kind of magical object, like a staff. Girl power!

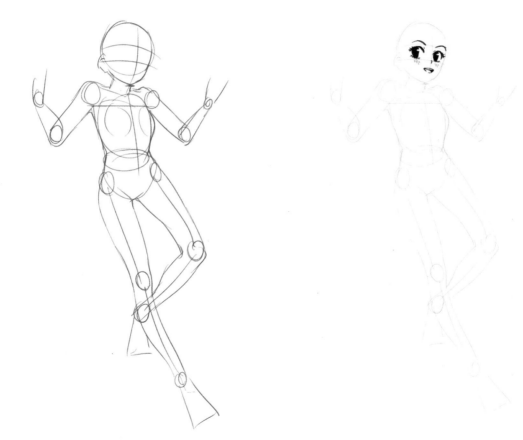

1. Draw out the proportions of her body. One leg will be partially covered by the other one.

2. Start with the face. Magical girls will have big eyes and are usually (but not always) characters who are often cheerful.

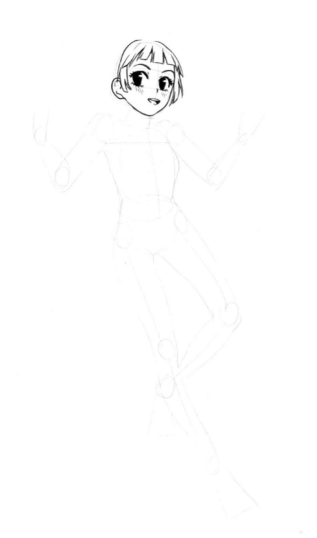

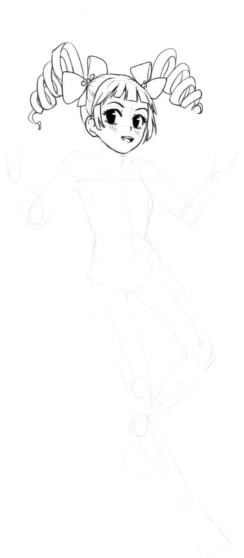

3. Finish her face and start with her hair.

4. Draw in her pigtails. You can use a spiral motion for these, looping the hair in circles.

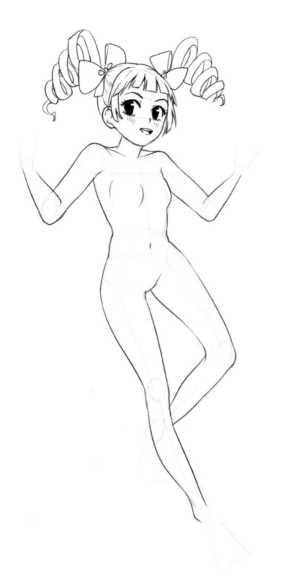

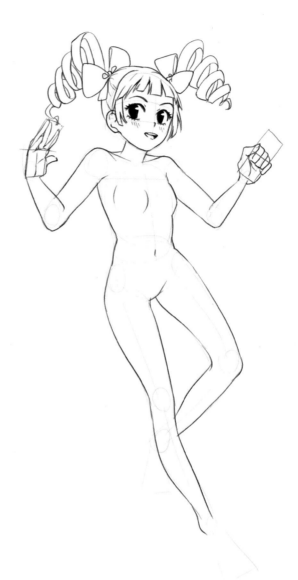

5. Draw in the outline of her body.

6. Use rectangles to draw in her hands. One hand is clutched into a fist because she'll be holding a wand.

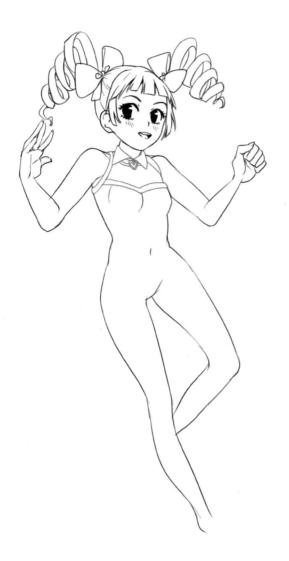

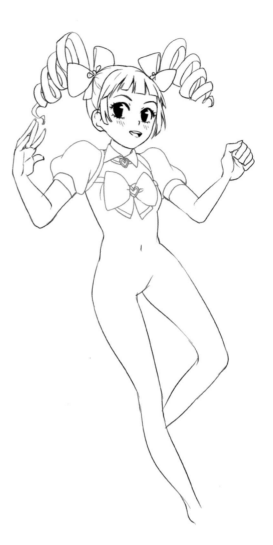

7. Start on the top of her dress. Hearts are popular with magical girls, so notice the heart just below her throat.

8. Put in her puffy sleeves. Draw in her bow and include another heart in the middle of it.

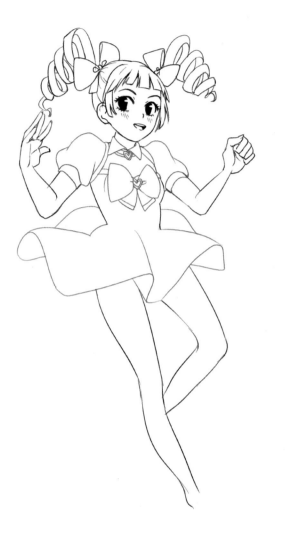

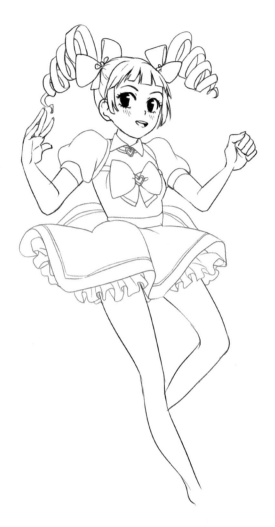

9. Do the basic outline of her skirt. Draw waving motions to get the flow of it.

10. Once the basic outline of the skirt is there, you can add designs and frills.

11. Outline for her feet.

12. Draw in her ribboned
 shoes.

13. Start with a stick
 shape for her wand.

14. Draw in the ribbon.

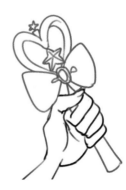

15. Put a heart on top
 of the ribbon.

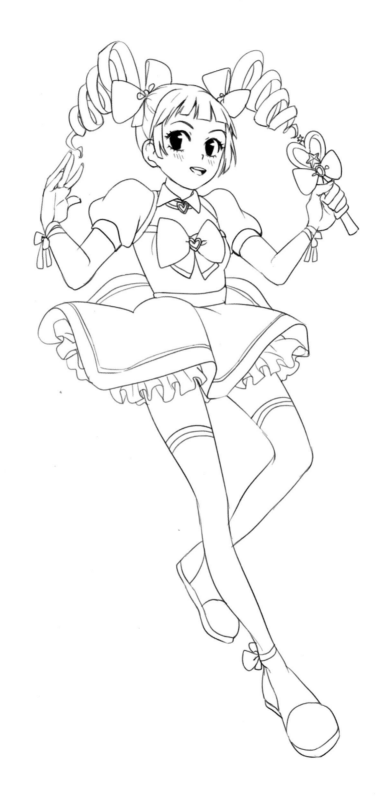

Butler

Butlers have really grown in popularity in manga. Butlers are often drawn as handsome, sometimes dangerous, and sometimes dangerously handsome.

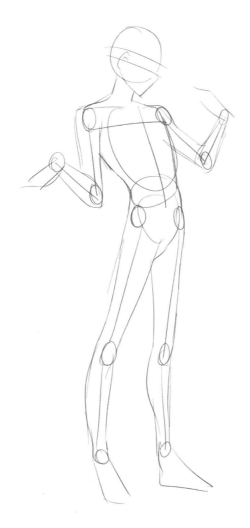

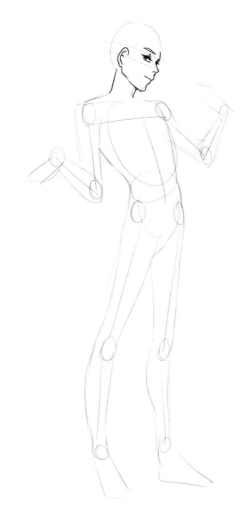

1. Draw the outline. A butler will probably be lanky. Make a curve in his back to have him lean forward.

2. Start on his face. He will have small eyes and a strong jaw.

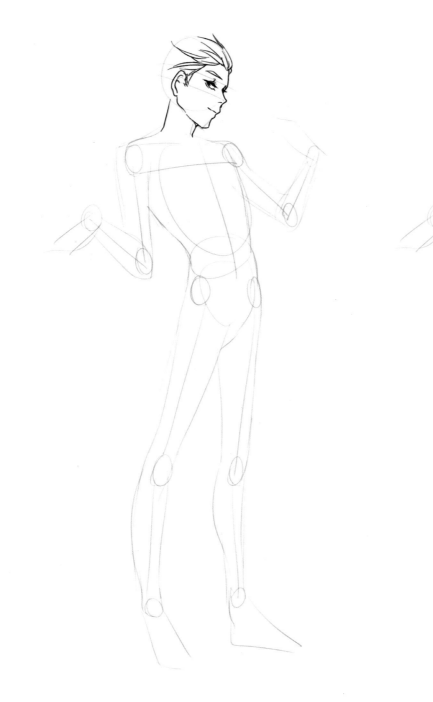

3. Begin on his hair. Watch how the hair is slicked back from his face.

4. Finish his hair. Watch how the hair moves back from his face and goes a little past the original circle for his head.

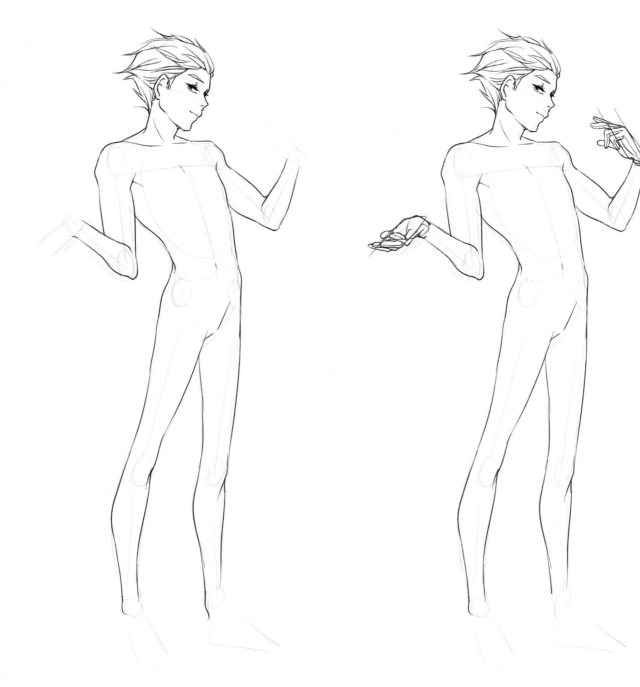

5. Outline his body.

6. Draw in his hands. Keep in mind
 butlers wear gloves.

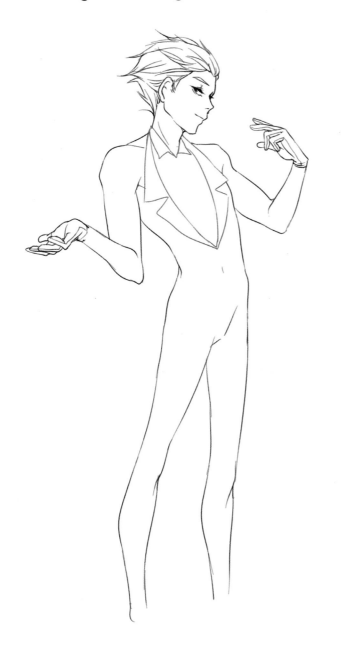

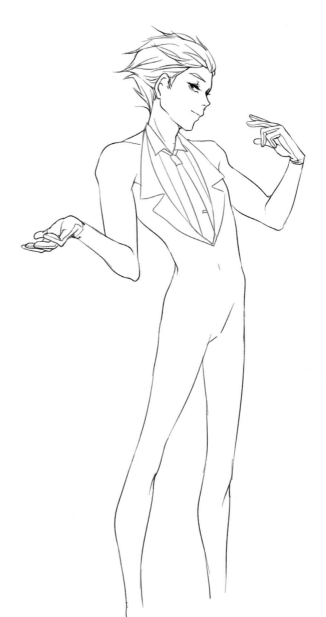

7. Begin on his suit. Notice how the opening of the suit should reach down to about his stomach.

8. No butler would be complete without his tie.

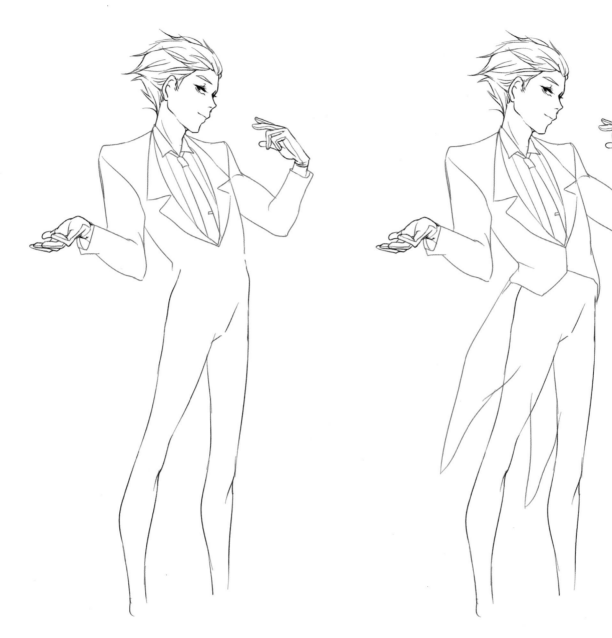

9. Draw in more of his shoulders. Keep
 in mind his suit's shoulder pads,
 which will broaden his shoulders.

10. Finish his coat. Add his coattails.

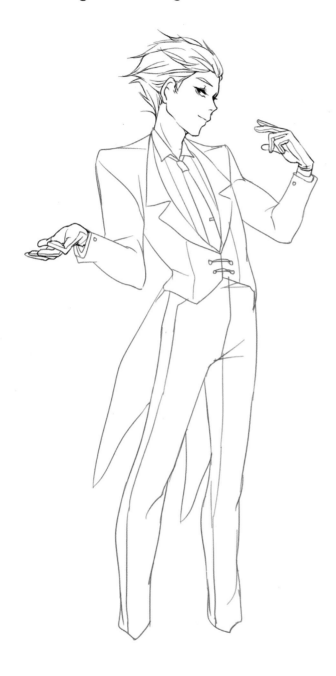

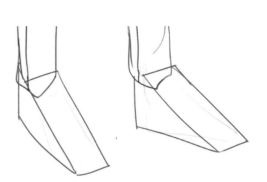

12. Outline for his feet.

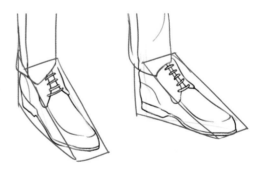

13. Draw in dress shoes.

11. Draw in his pants. Include seams and
 creases. The pants will be only a little
 thicker than his legs.

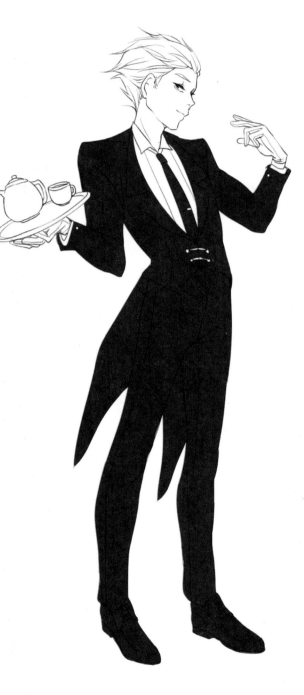

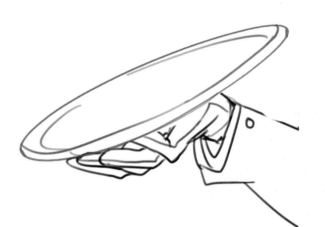

14. His plate will have an oval shape. Three lines within the oval will give it dimensions.

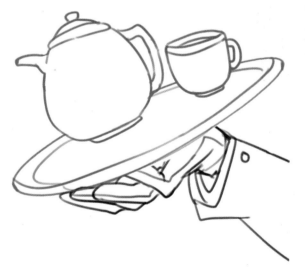

15. Put in a teapot and teacup.

16. You can color your butler in different shades.

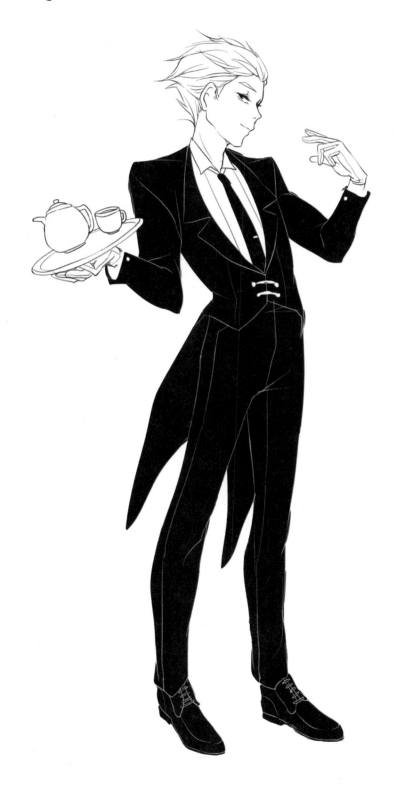

Maid

Maids are a common motif in manga. They can be used as kind of flirty or sexy characters, or totally serious, like with the *Emma* series. Maid cafes are popular in Japan, so if you ever visit one, you'll have to show off your maid drawings!

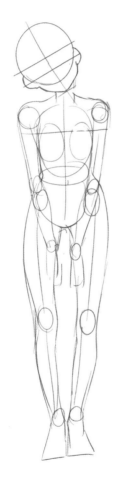 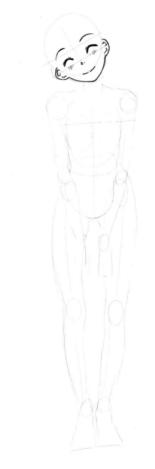

1. Draw in your proportions. Her head will be tilted to the side but still go by the same guideline rules.

2. Begin to draw in her face. Notice how the thick curves show that she is happy and also that her eyes are shut.

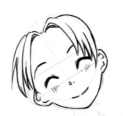

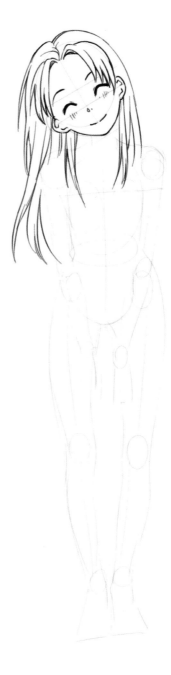

3. Begin on her hair. Because of the tilt, her hair will be drifting in that direction.

4. Finish her hair. Keep having it drift to the side.

5. Put in a headband.

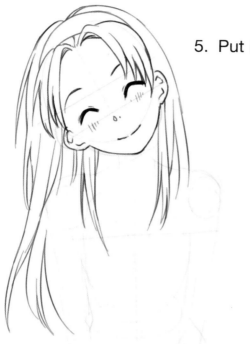

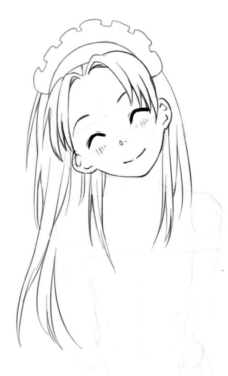

6. On top of the headband, draw in a basic jagged shape, kind of like a castle.

7. Once the basic shape is there, you can fill in the frill.

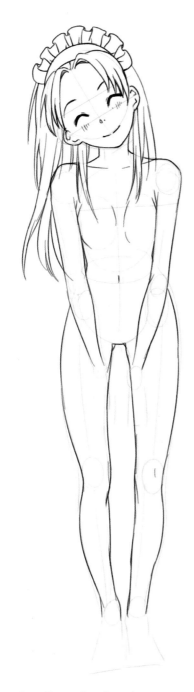

8. Outline the body.

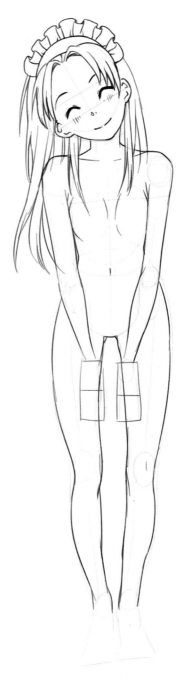

9. Put in rectangles to guide your hands.

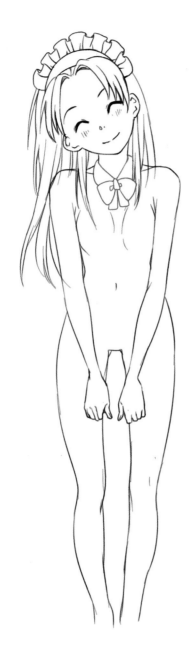

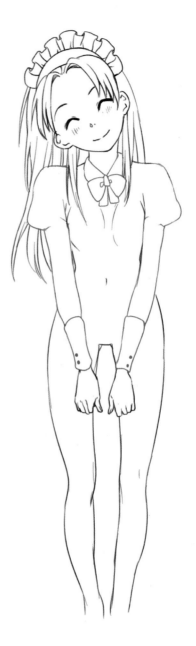

10. Draw in her collar and bow.

11. Put in her sleeves. The top of the sleeves will be puffy, but the rest will be skintight.

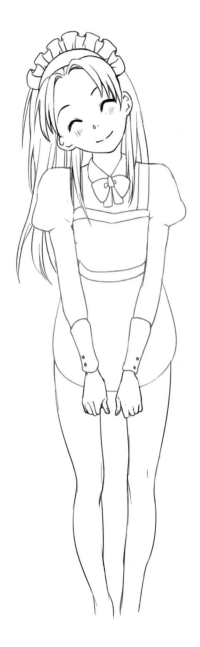

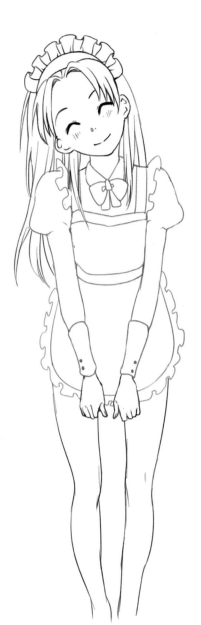

12. Finish her sleeves, including buttons. Draw what looks like a very short, tight skirt—this will be her apron.

13. Put in the frills around her apron. Don't forget the frills by her shoulders.

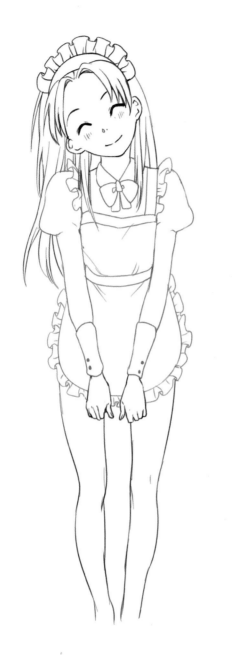

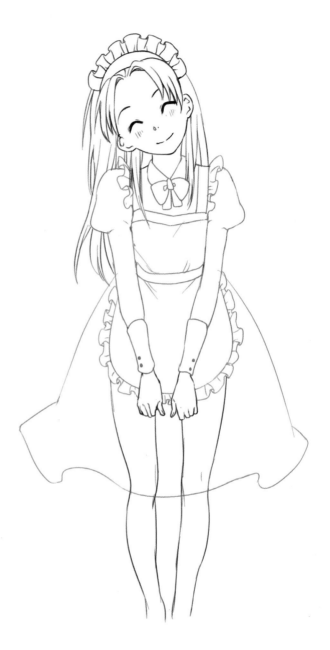

14. A few little lines here and there in the middle of the frills give them depth.

15. Draw an outline for a bell-shaped skirt.

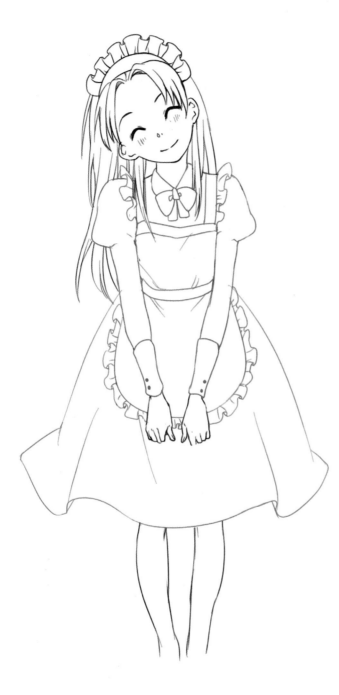

17. Outline the area for her shoes.

16. Put creases into the skirt to show how it moves.

18. Draw in her fancy heels.

19. For the dress's frills, start with this jagged outline.

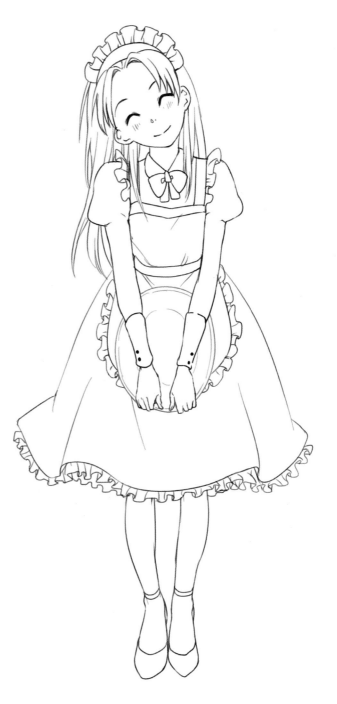

20. Use lines to finish the frills and give them depth.

21. Put in the platter she's holding. Notice the lines just inside the platter and in the middle.

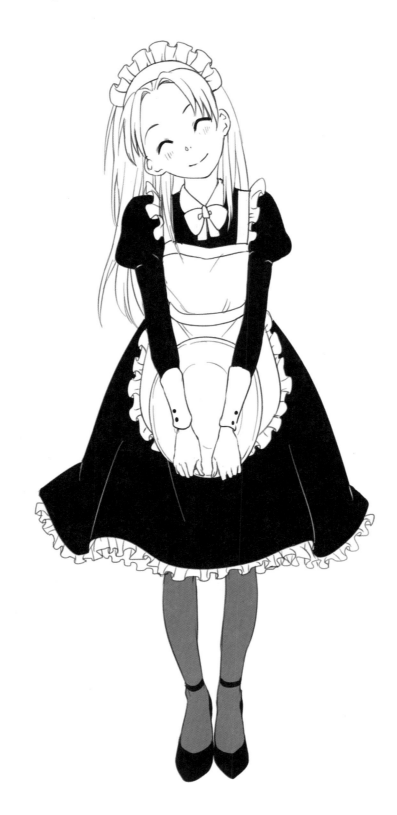

Woman in Kimono

The kimono is one of the most recognizable forms of Japanese clothing. These robes are beautiful and come with different styles and patterns. Keep in mind for your own manga that kimonos are often heavy in symbolism and that people of different ages, sexes, time periods, and in various settings will wear different types of kimonos. The details of a kimono can be pretty complex, so we're really going to break down the steps for the drawing here.

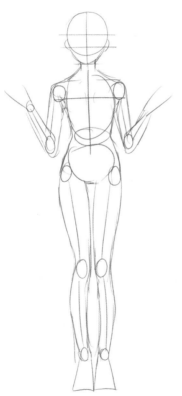

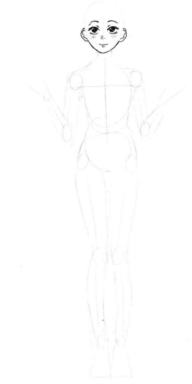

1. Outline the body's proportions. Have her hands be about shoulder level and her elbows not far from her hips.

2. Draw in the eyes and start on her face.

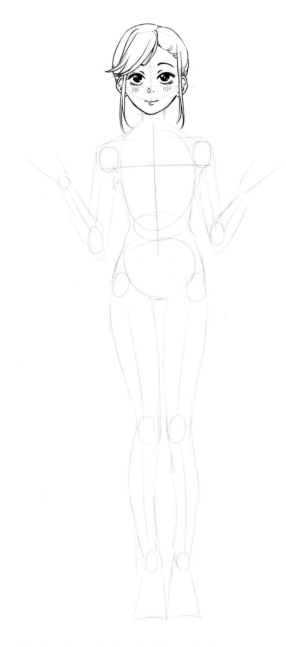

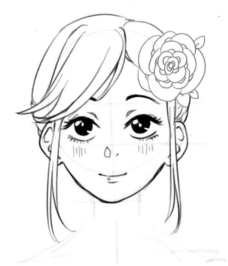

4. Add a rose to her hair.

5. For the rose, start with a single circle.

6. Do two loops from that circle.

7. Do two more loops from the circle, but from the other side.

3. Finish her hair. Let the hair on the right side of her head (your left) sweep to the side.

8. Continue the loop pattern. Watch how the loops get bigger as you move away from the center of the rose.

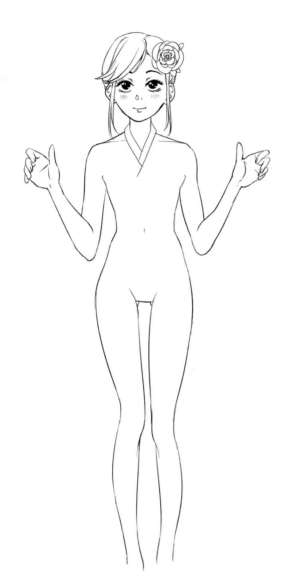

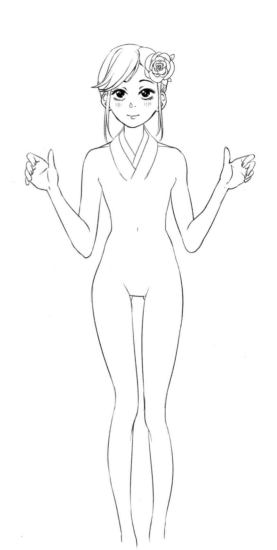

9. Start simply, with her collar. Remember, a kimono will be wrapped left over right.

10. Add to the collar.

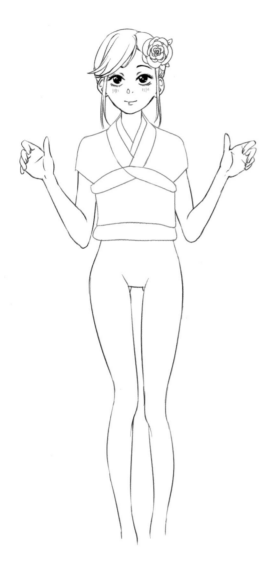

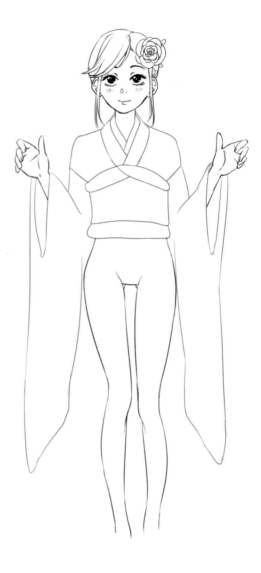

11. You'll be adding two folds under the collar. This is actually the start of her *obi*, or sash.

12. Once the obi is finished, give her very long sleeves.

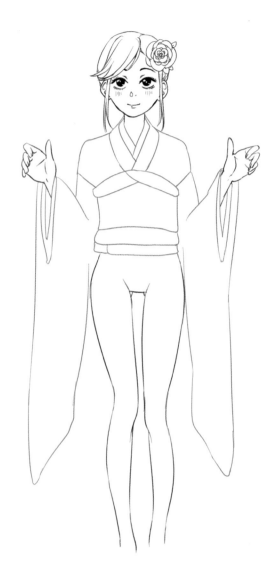

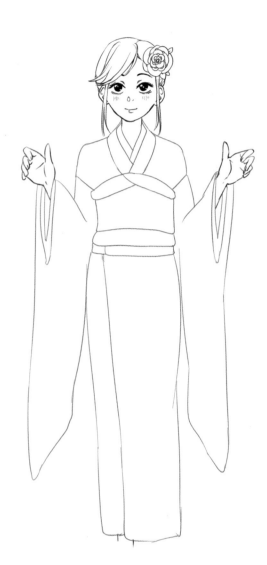

13. Add an inner oval to her sleeves. Draw another line underneath the *obi*.

14. Draw down to the bottom of her kimono's skirt.

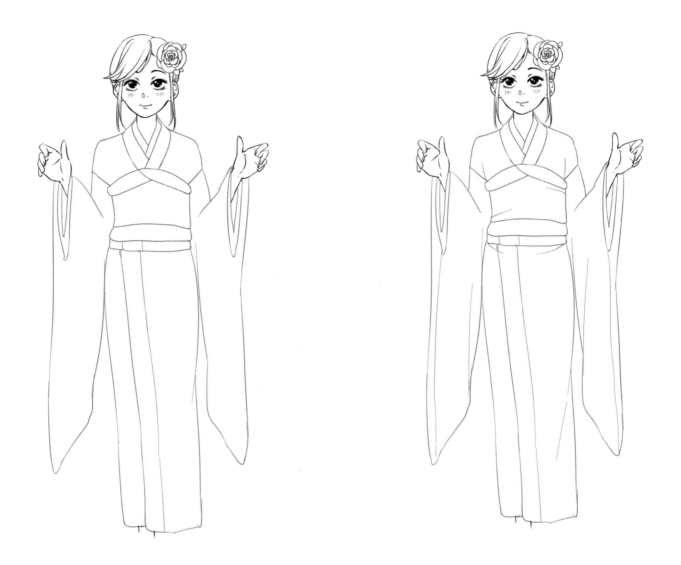

15. Add another line down to the bottom. 16. You're almost there! Put in creases.

18. Draw in an outline for her feet.

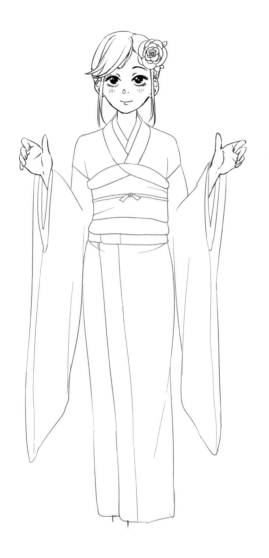

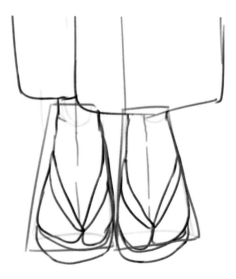

17. Put a tie around the center of her *obi*. Feel free to draw in any patterns you wish for the kimono, especially if you want to add symbolic references.

19. Draw in sandals. The sandals will separate one toe from the rest.

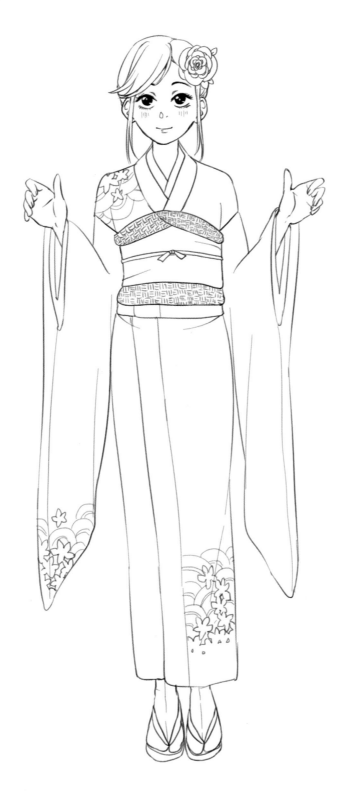

Female Ninja

Ninjas got their start as mercenaries in feudal Japan and they've become popular in manga, including in mega hits like *Naruto*. In real life, a ninja in feudal Japan probably would have worn regular clothing to fit in, but if we're talking ninja in manga, there's a good chance they look something like this.

1. Draw the outline. Give her a strong stance with her feet past her shoulders.

2. Start on the face. Drawing her eyebrows down helps show how serious and concentrated she is.

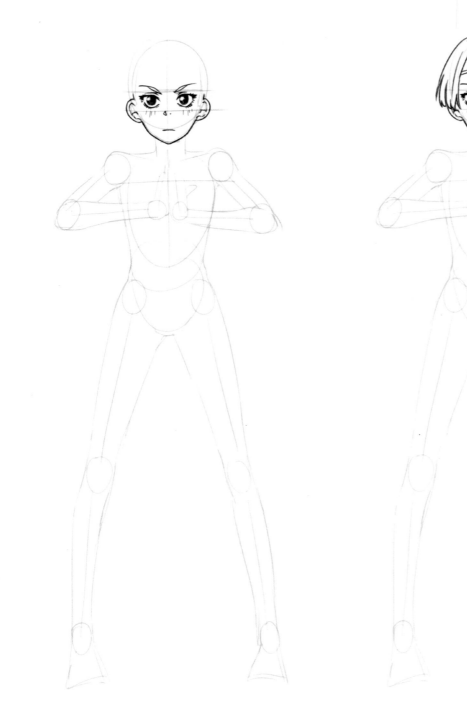

3. Continue with her face. She's
 looking at you straight-on.

4. Draw in a headband. Have some
 of her hair fall forward over it.

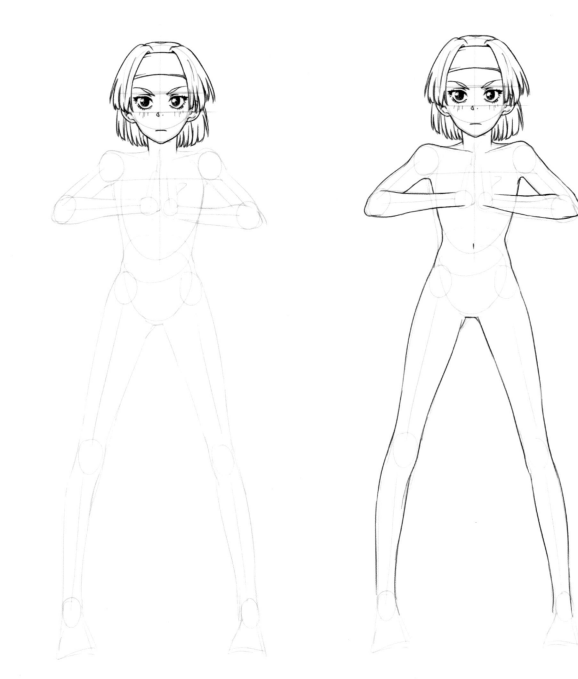

5. Finish her hair. The hair in the back won't go as far out as the hair in front.

6. Outline her body.

7. Draw in a rectangle for her hands.

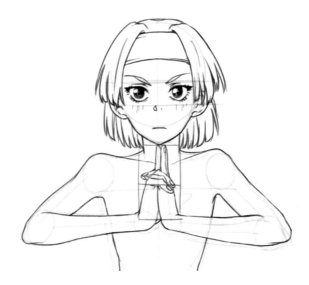

8. Her hands are doing a chakra hand sign. Watch how the fingers fold over each hand.

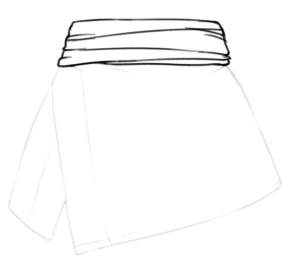

9. Start on the top of her skirt.

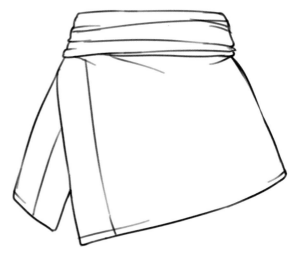

10. Finish her skirt. Give it creases in the corners.

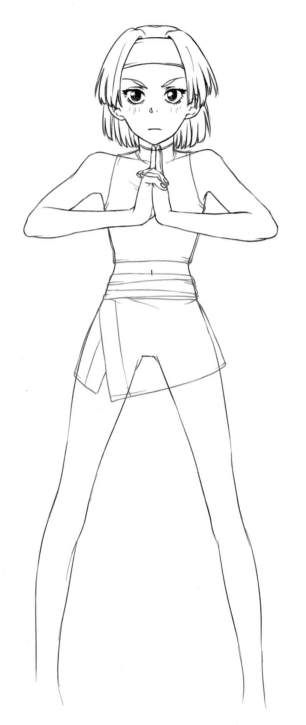

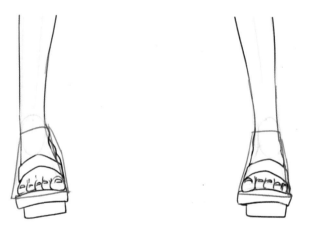

12. Draw an outline for her feet.

13. She's wearing *geta*, a type of Japanese sandal that has two blocks of wood underneath it like teeth. Because you're looking at it from the front, you'll just put in the front tooth. More on *geta* in the male ninja drawing.

11. Put in her shirt. It will fit tightly on her and go halfway up her throat.

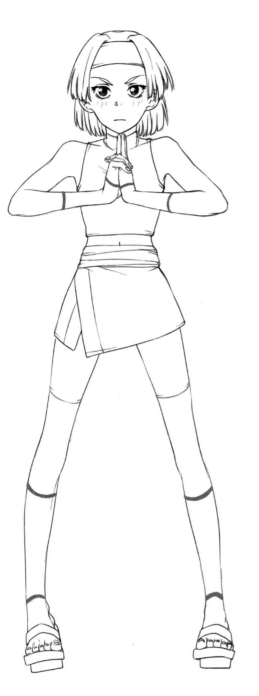

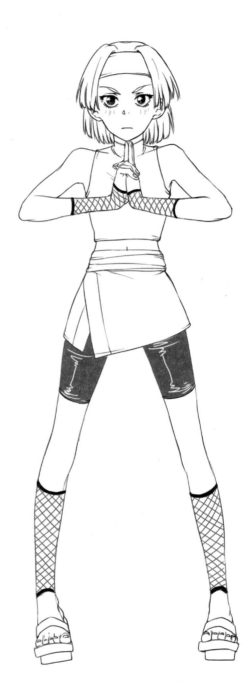

14. Put in the lines for where her netting and leggings will go.

15. Draw in the netting. All you're making are interconnected lines. Color in her leggings, but leave some white for reflection and creases.

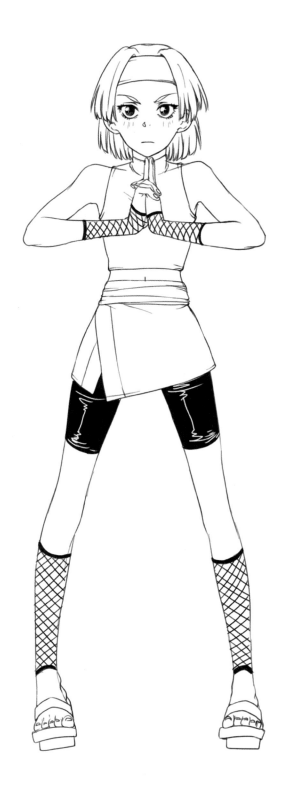

Male Ninja

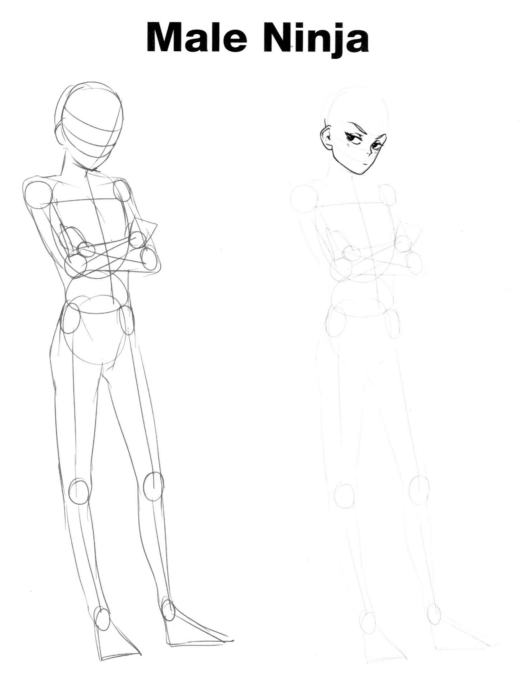

1. Draw in the outline, making him lithely muscular. His front leg will be leaning back, and the knee of his back leg will be poking out a little.

2. Draw in the face. Partially closed eyes give him a coolly annoyed look.

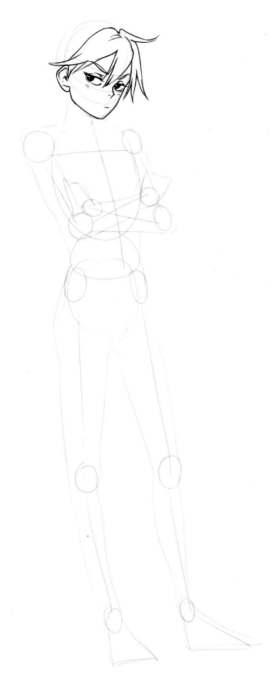

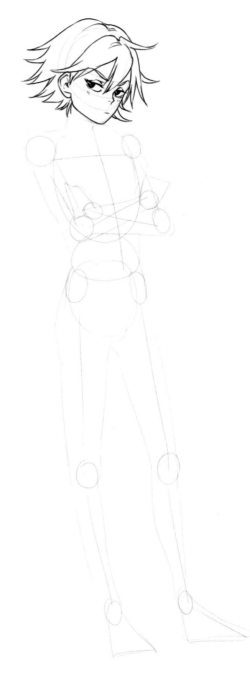

3. Begin on the front of his hair. Put in the bangs between his eyebrows.

4. Continue and finish his hair. It can have more of an anti-gravity look in the back.

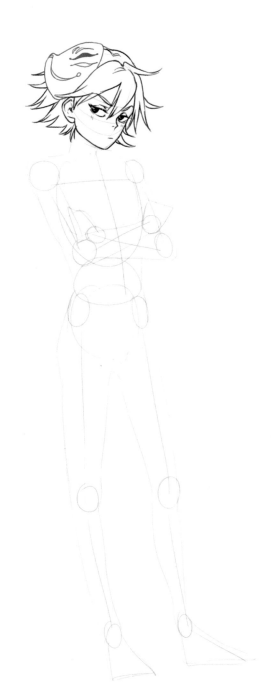

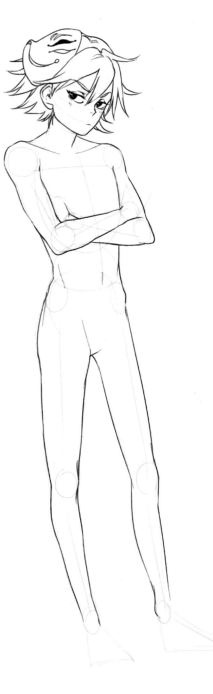

5. Draw in his mask. Masks can have a lot of symbols. If your ninja has a backstory, his mask might reflect that.

6. Outline the shape of his body.

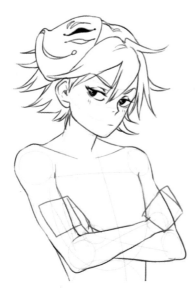

7. Outline a guideline for his hands.

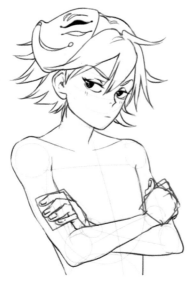

8. Draw in his hands. The thumb on his left hand will be hidden in his arm. The fingers on his right hand will be mostly hidden, but you do want to draw in his thumb and knuckles.

9. Start on his shirt, which will look kind of like a vest at first. It will be slightly thicker than his body. This will be most noticeable around his midsection where the fabric is baggier.

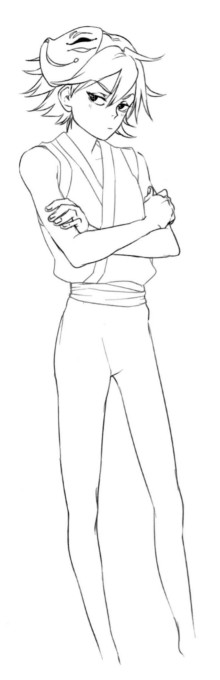

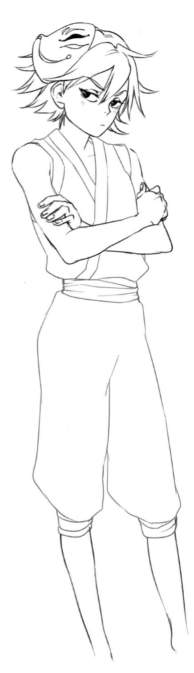

10. Finish the outline of his shirt and draw in a rumpled sash (or *obi*) around his waist. Just a few lines will bring out the rumples.

11. Draw in some more lines to finish his shirt. Give him baggy pants down to his knees.

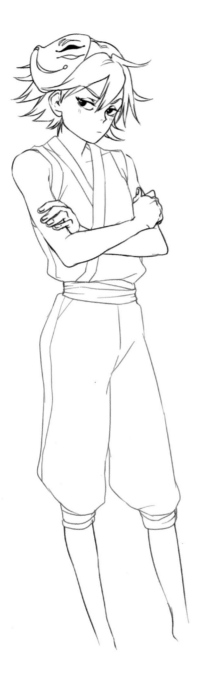

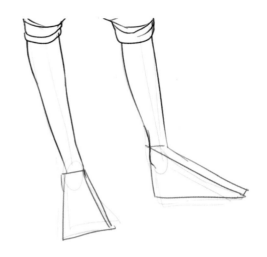

13. Draw in the outline for his shoes.

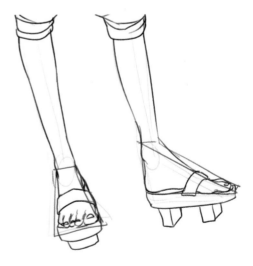

12. Crease his pants so they look real.

14. Draw in his shoes. On his left foot you can see both teeth of his *geta*.

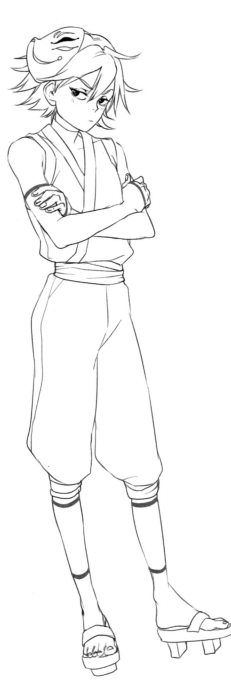

15. Put in lines for his netting and undershirt.

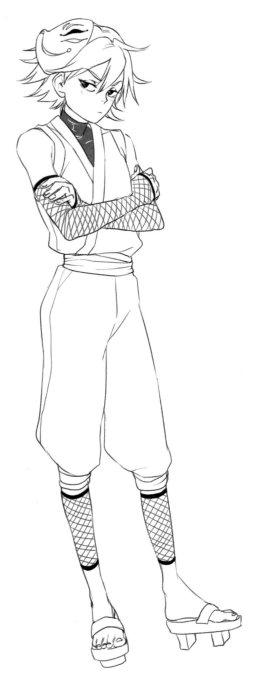

16. Do crisscross lines for the netting. Color in his undershirt.

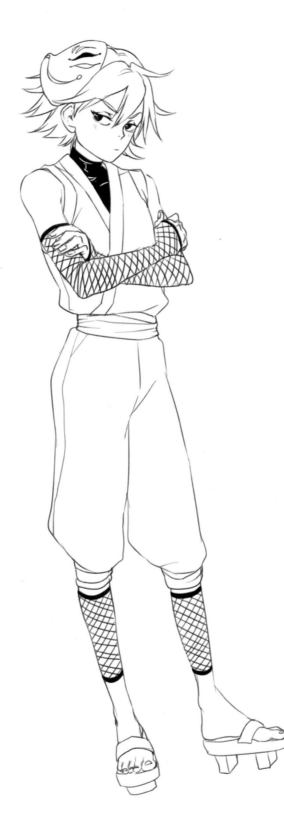

Woman in *Yukata*

A *yukata* is a type of Japanese robe that's especially popular to wear during the summer months. It is not as ornate as some kimonos.

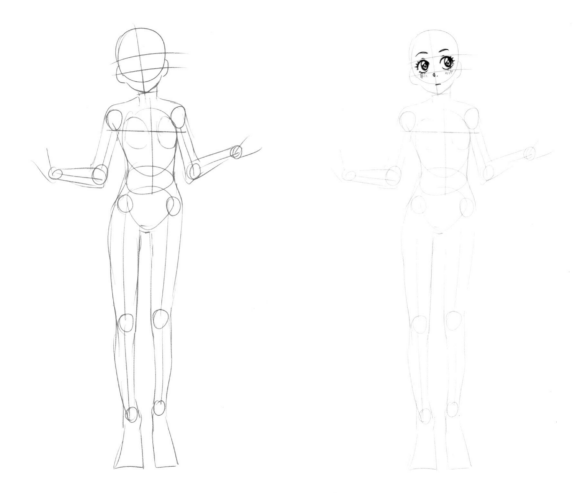

1. Draw in her outline. Have her arms lifted up partway and give her head a slight tilt.

2. Start on her face. She's looking off to the side.

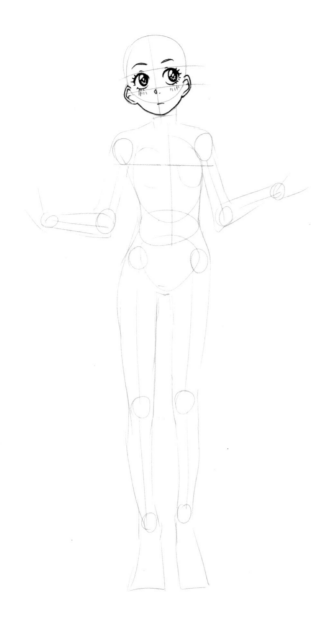

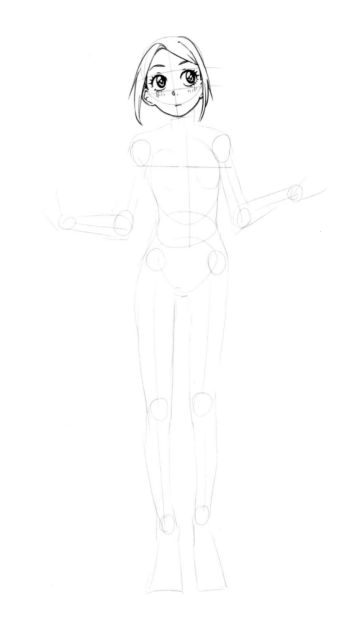

3. Draw in the outline of her face.

4. Start on the front of her hair. Make some of the hair tuck back behind other strands.

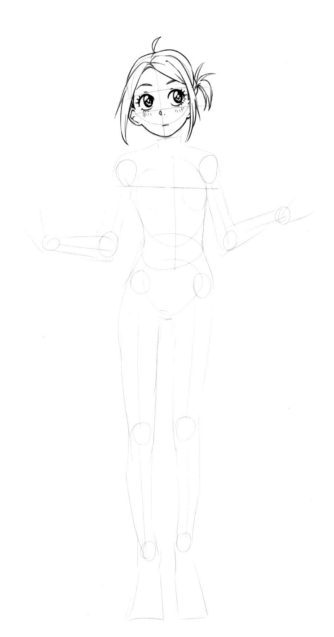

5. Put a feather of hair on top of her head.
 This feather is really called an *ahoge* in
 Japanese. Her hair is pulled back, and
 that is evident because of the position of
 her head. For the back of her hair, draw
 four spikes of hair—two pointing up and
 two pointing down.

6. Outline her body.

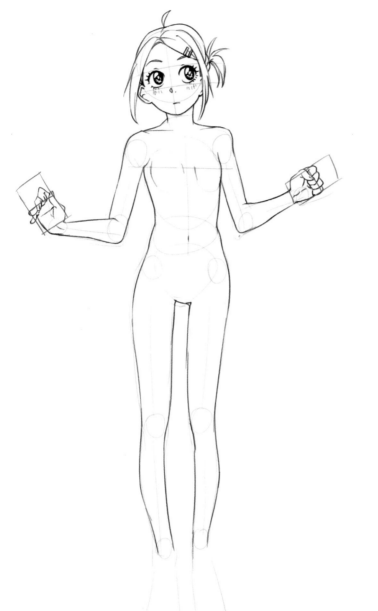

7. Outline and draw in the hands. One hand is clutched like a fist because she's going to be holding something. For the fist, the fingers will essentially be like four nubs. Two fingers are curled in and two are curled out on the other hand.

8. Start on the collar of her *yukata*. Her *yukata* will be folded left over right on her body.

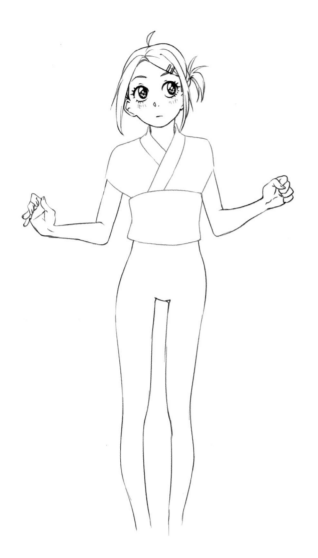

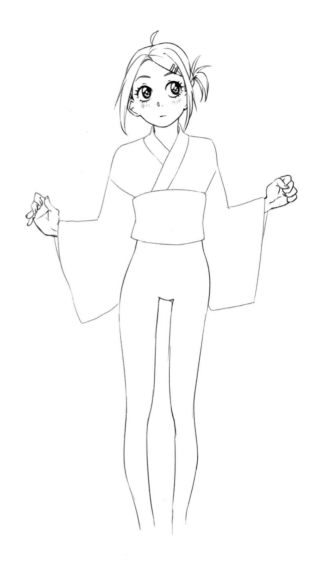

9. Draw the clothing around her shoulders and her thick *obi* (sash).

10. Draw in long sleeves. These, however, won't be as long as the sleeves in a kimono.

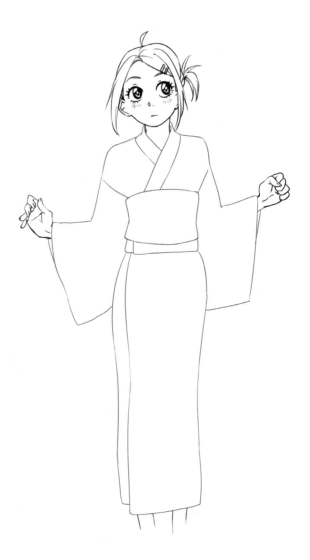

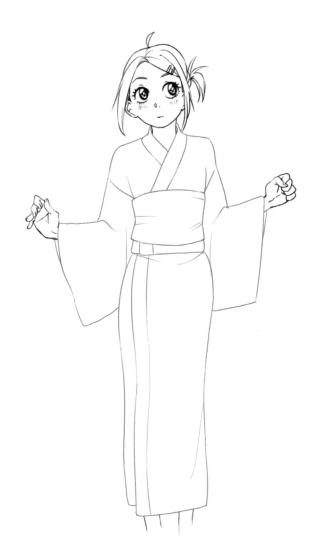

11. Draw in the skirt.

12. Add another line down the skirt.

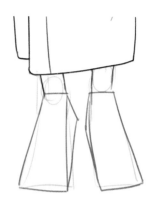

13. Draw an outline for the feet.

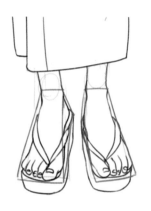

14. Draw in her sandals.

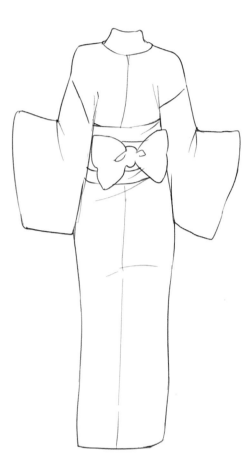

15. This is what a *yukata* looks like from the back, if you'd like to draw it. Note the bow in back.

16. For her bag, start with a loop going through her fingers.

17. Under the loop, draw a bell shape.

18. Add creases to change the bell shape into a bag shape.

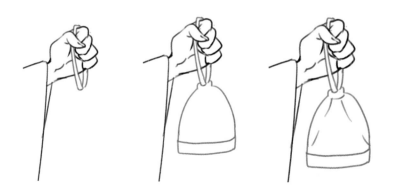

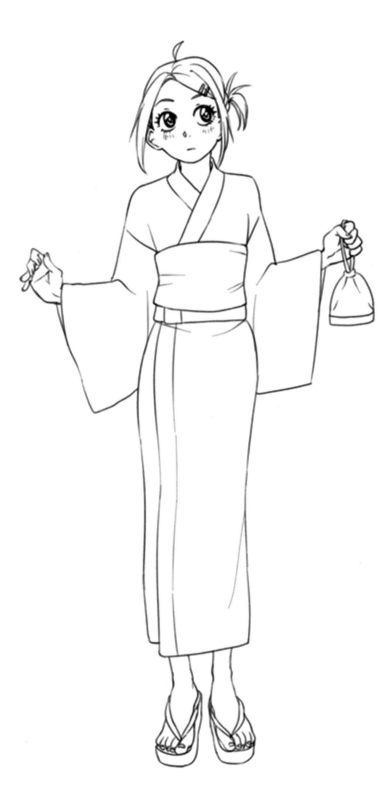

Lolita

Lolita is a style of fashion (or maybe even a lifestyle) that can sometimes find its way into manga. There are different forms of Lolita fashion, and in this style you'll see attributes like frills and wide skirts. Gothic Lolita—which mixes Gothic imagery with little girl imagery—is the most well-known globally. The Lolita style is popular outside of Japan with anime and manga fans called *otaku* and fans of Japanese fashion.

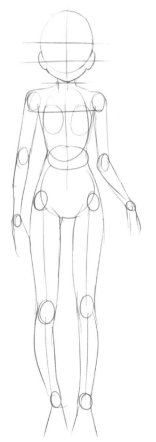

1. Start with the outline. Because we're going for kind of a cute shape, we're making her head a little bigger than average.

2. Make sure her eyes are large. The slightly lowered lids and straight brows give this Lolita something of a bored look.

3. Draw in her face and bangs.

4. Start on her hair. There will be some overlap with the bangs and some of the hair will cover her ears.

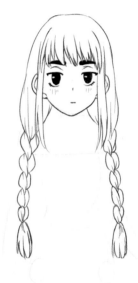

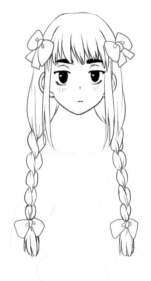

5. You'll be adding in braids under the initial hair you've drawn. Make sure there are the same number of braids on each side.

6. Lolita's appearance can be Gothic, but it should still be cute. Attach some ribbons to her hair.

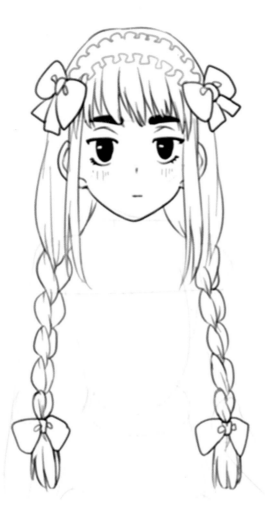

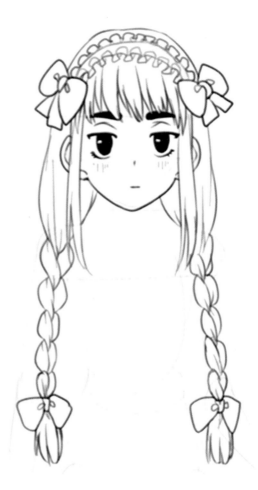

7. Getting up close, let's take a look at her head. Between the two ribbons you'll draw a frilly headband. Just do a simple set of frills at first.

8. Put a line under the top layer of frills. Give another layer of frills to the bottom to give it depth.

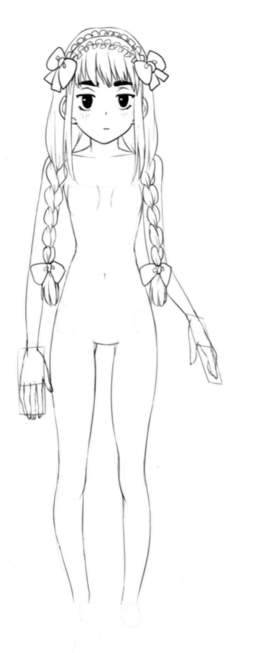

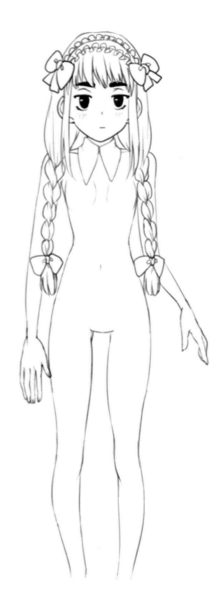

9. Outline the body. Use rectangles to draw out the hands.

10. Her dress is complicated, so let's take this slowly. Start with the collar.

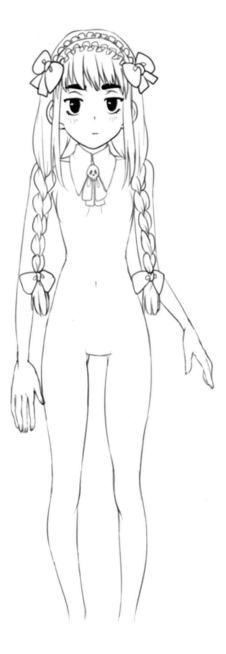

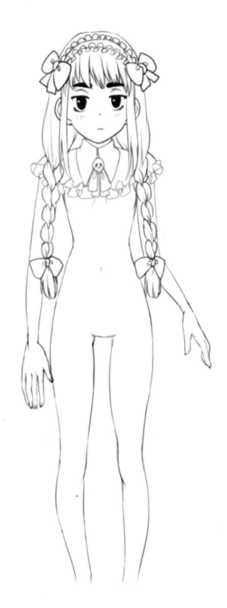

11. Under the collar, put in a skull and some more layers. The skull will be shaped similarly to a person's regular face, only you'll be putting in teeth instead of a chin.

12. Start on the top of her dress. Put in frills going from shoulder to shoulder.

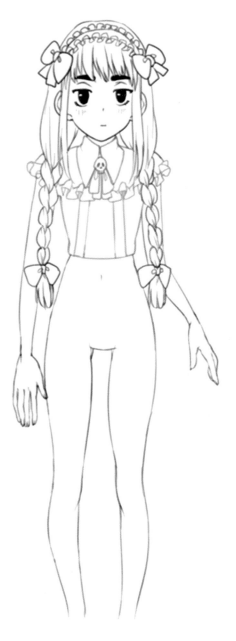

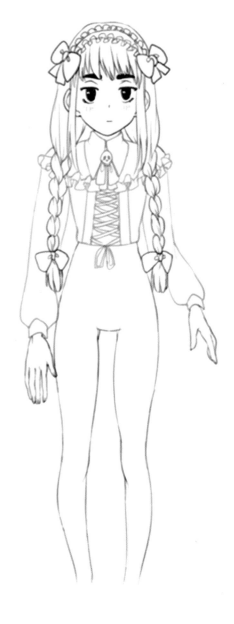

13. Draw the clothing in down to her waist. Put in two lines that look kind of like suspenders.

14. Put in slightly puffy sleeves. Those two "suspender" lines will actually be for her corset. Draw interconnecting lines through the middle to show the laces.

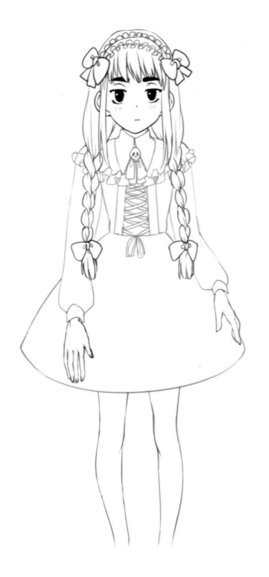

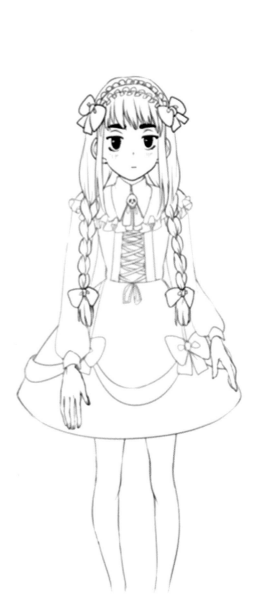

15. Give her the outline of a hoop skirt. With Lolita fashion like this, it's important it's a full skirt and doesn't fall down straight.

16. Add some ribbons.

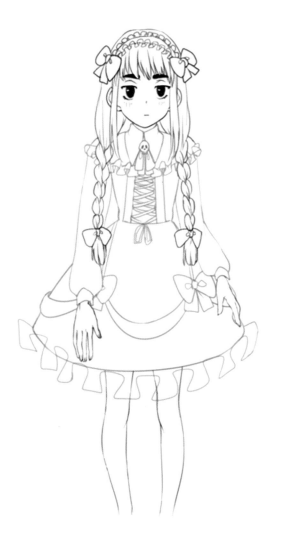

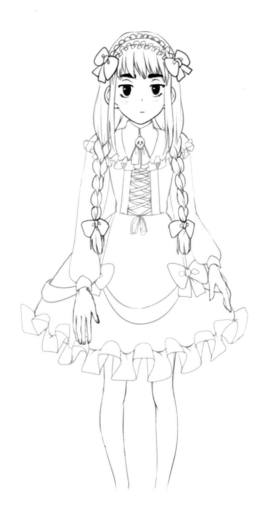

17. Begin the frills around the bottom of her dress. When you do the frills one layer at a time, it really works well.

18. Finish off the frills at the bottom of her dress.

19. Create the outline for her shoes.

20. Clogs are popular with Lolita fashion, as are Mary Janes, ribboned shoes and some combination (ribboned Mary Jane clogs, anyone?).

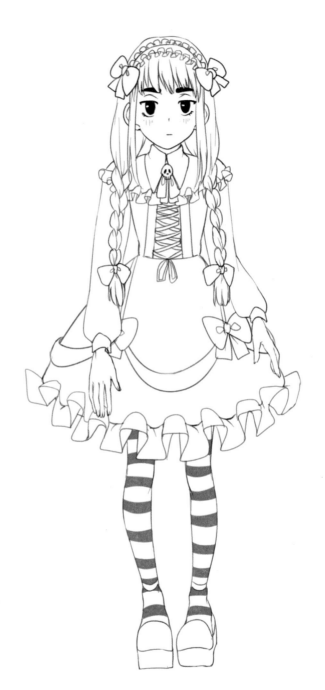

21. Stockings add well to the look we're trying to achieve. Alternate color stripes up her legs, and make sure you don't color over the top strap of her shoes.

Bishonen

Bishonen means "beautiful boy" in Japanese. The pretty boy style is very popular with female readers, especially when making *shonen-ai* (boys' love) or romantic manga.

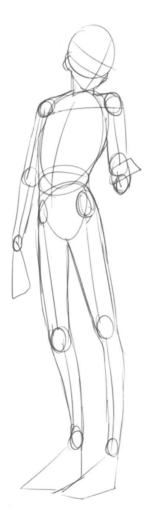

1. Start with the outline. *Bishonen* boys tend to be lithe, but you can also make them more solid and give them bigger shoulders. Because of the way his hand is held out, the hand will be level with his elbow.

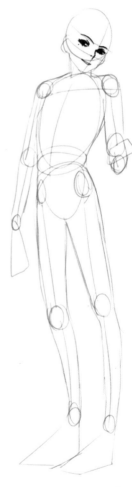

2. Depending on the type of *bishonen* you want, you can give him bigger or smaller eyes. Younger, more innocent *bishonen* will have bigger eyes. This *bishonen* type seems pretty slick and sure of himself, so let's give him smaller eyes to add to that effect.

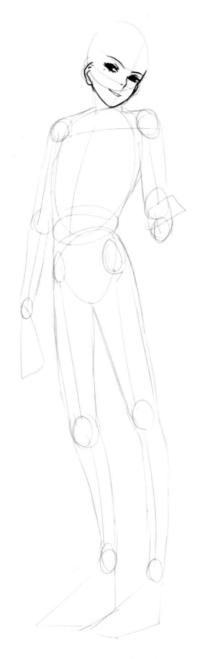

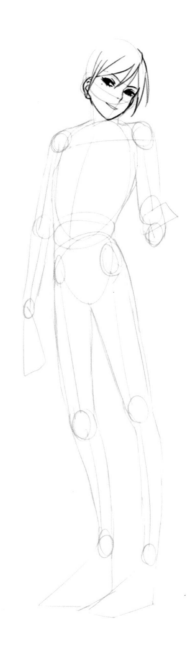

3. Start to fill out the face.

4. Begin with the hair around his face. *Bishonen* typically have very beautiful hair that's an important part of their image, whether the hair is short or long.

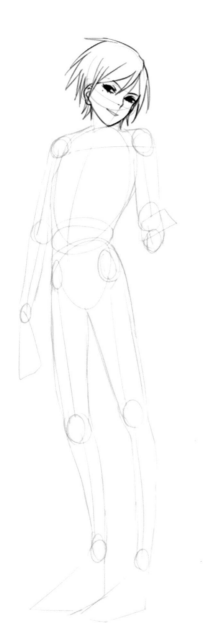

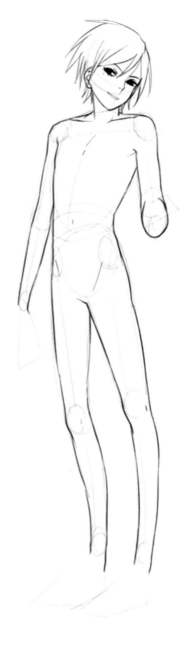

5. Continue to fill out his hair.
 Bishonen tend to have softer
 hair compared to the spikier
 hair you see in some other
 male characters.

6. Draw in his body.

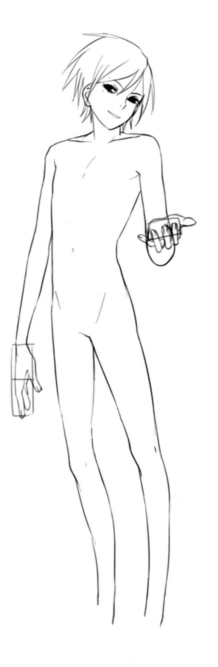

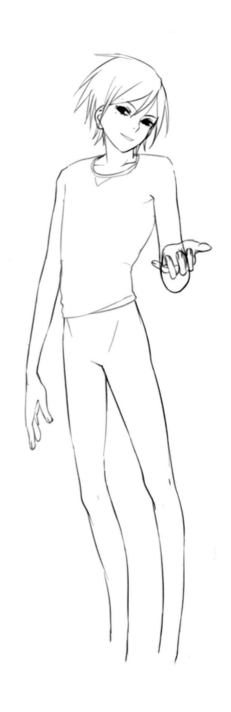

7. Draw in his hands. His lifted hand is trickier—you want the curve of his palm on top. Three fingers will face the audience. His smallest finger will be jutting to the side and you'll only see the underside of his thumb.

8. Start on his shirt. It will be skin tight.

9. *Bishonen* are known for their flair for style. Put some wool around his shoulders for the hood of his coat. The wool will have a cloudlike structure.

10. Draw in his coat, letting it curve away at the back. If he's just standing there, this curve gives the image a certain elegance and dramatic effect. *Bishonen* are known for both these traits.

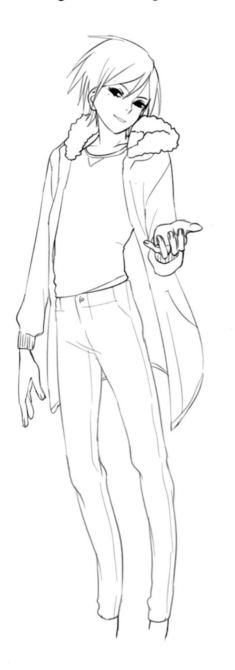

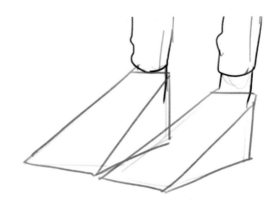

12. Make an outline for his shoes.

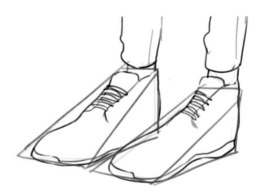

13. A pair of straightforward, laced shoes work fine. If you want to up the style, you might also consider giving him boots.

11. Give him a pair of well-fitting pants. Remember the creases.

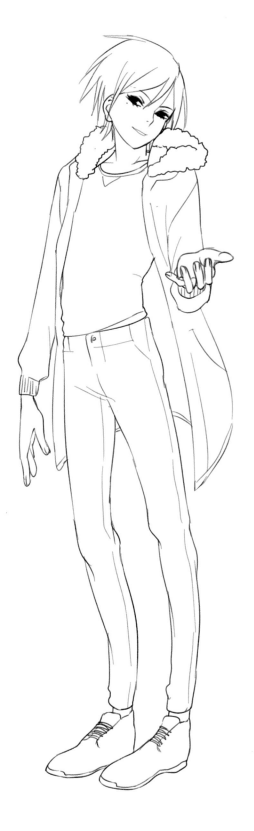

Chibi

There's nothing cuter than a *chibi* drawing! Sometimes a manga will have nothing but *chibi* characters, or sometimes the characters will "turn" *chibi* for a panel or two in order for the artist to get his or her point across. For instance, a character might turn *chibi* when feeling a really strong emotion, like joy or excitement.

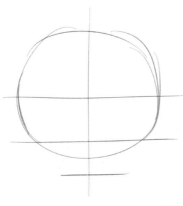

1. Typical manga proportions get thrown out the window with *chibi*. Instead of starting with the usual proportion outline, let's start with the head by drawing a circle and putting our guiding lines in.

2. Use the guiding lines to put in the ears.

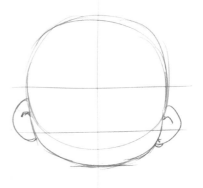

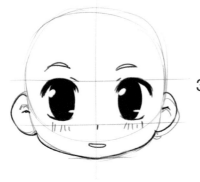

3. With *chibi*, it's important that the eyes are absolutely enormous. That's part of the pull with *chibi* characters.

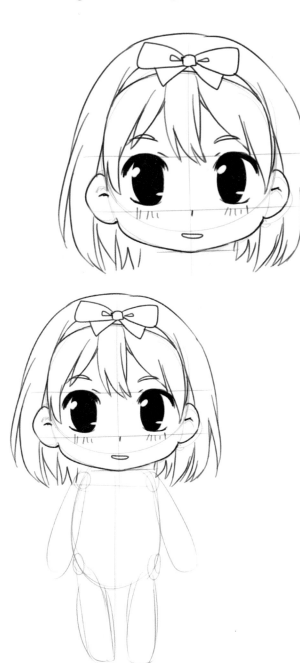

4. Draw in her hair. A bow in the middle of her head gives an extra level of adorableness.

5. Next draw her body. *Chibi* bodies are small and somewhat rounded. The body will be in or around the same size as the head.

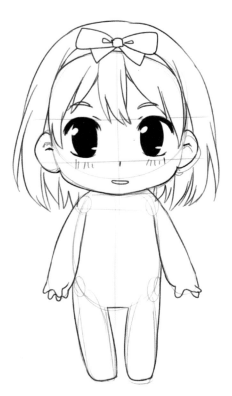

6. Draw in her hands. The palm will not be the same length as the fingers. The fingers will be puffy and tiny. With *chibi*, think smallness (unless we're talking head and eyes) and roundness. Think cute.

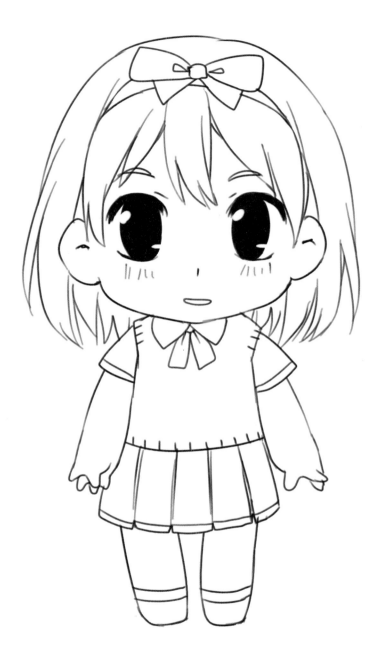

Hero

Your manga won't be complete without its hero or heroine. Our hero has a bit of a Medieval quality, which can be popular in fantasy manga. But feel free to change up his outfit—just remember his heroics and stance!

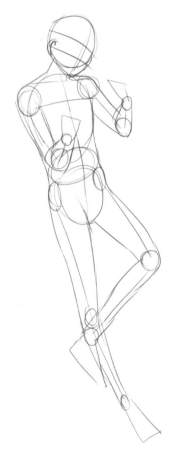

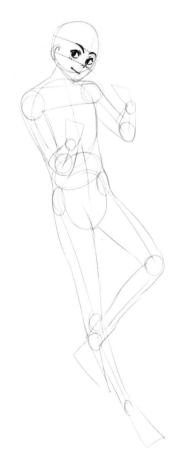

1. Start with his proportions. His shoulder facing you will be broader than his other shoulder.

2. Work on his face. He has a little smile. He's not vain about it, but he definitely knows he's a hero.

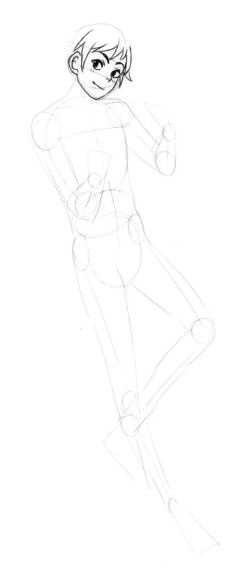

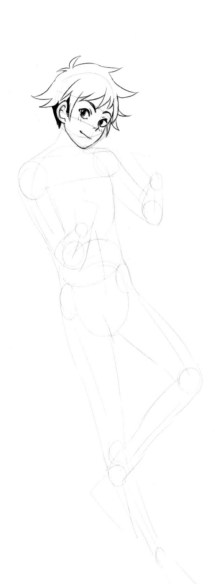

3. Outline his face and start on his hair. He'll have a boyish quality, which will be brought out with his big eyes, small smile and spiked hair.

4. Continue on his hair. There will be two little tufts of hair on the back of his head, but the rest of the spiky hair should be closer to the face.

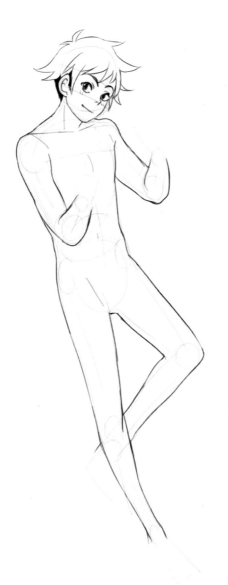

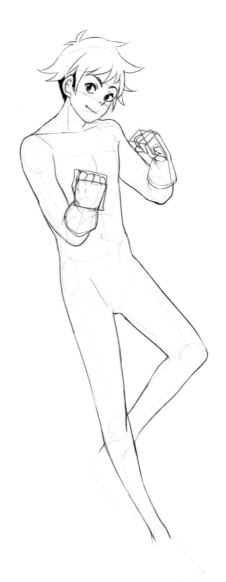

5. Outline his body. Because of the angle, you'll draw short lines for his arms.

6. Draw in his hands. Give him gloves that go up his forearms.

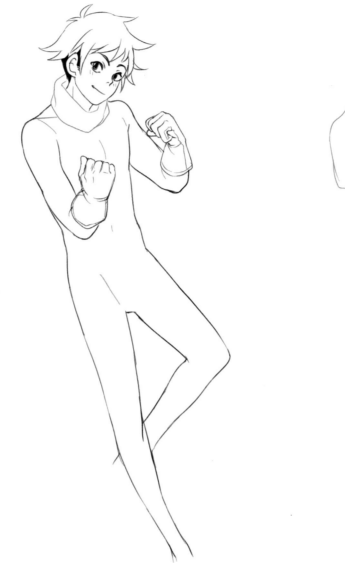

7. Draw in his scarf. It will be a thick scarf and loose around his throat.

8. Draw in the sleeves of his shirt.

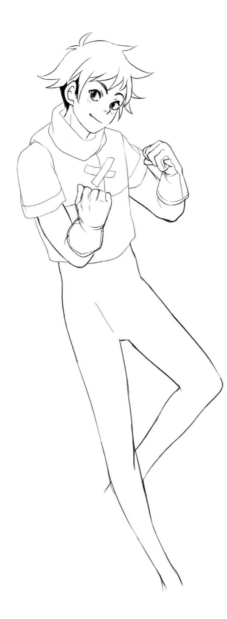 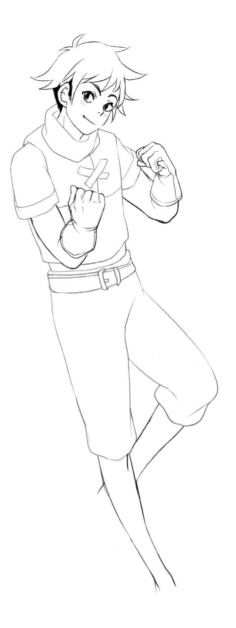

9. Finish his shirt. Put an X over his chest.

10. Draw in his pants and belt. The pants will be thicker than his legs.

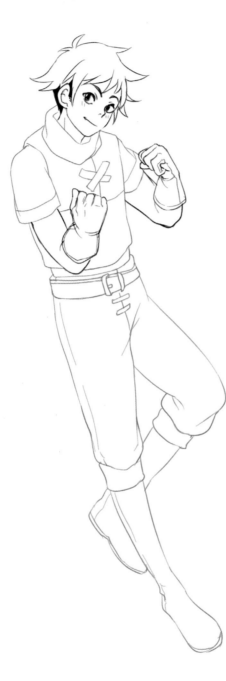

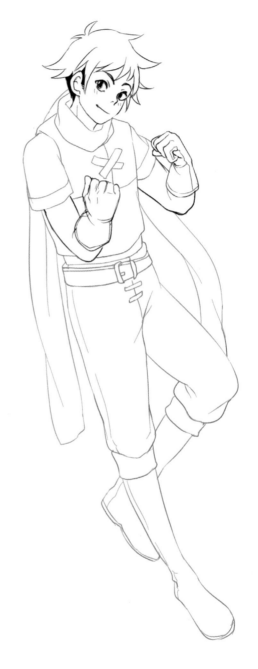

11. Give him long boots and add creases.

12. Finish the length of his scarf. Make it billowy instead of falling straight down.

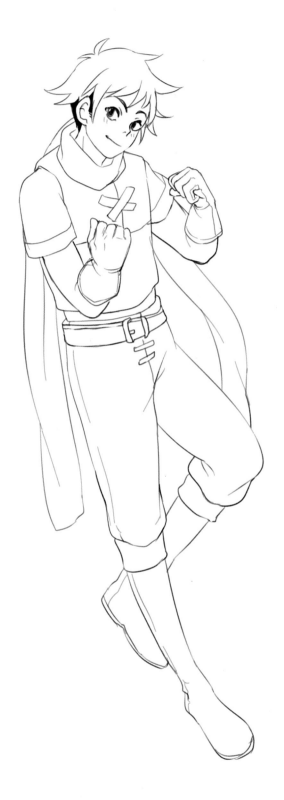

Heroine

If you have a hero, you'll also have to have a heroine. This young woman has a sword and a great sense of self.

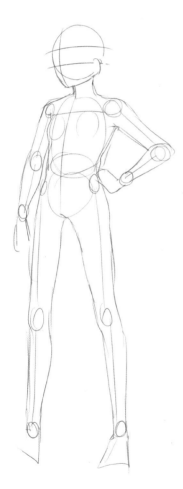

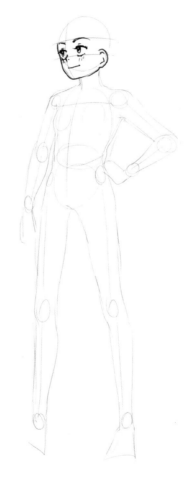

1. Draw the proportions. One hand will be on her hip with the elbow pointed out.

2. Draw in her face. Like the hero, she'll have a vague smile.

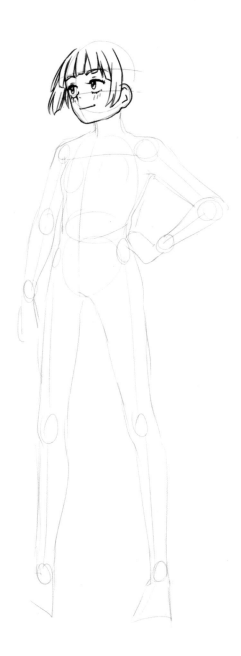

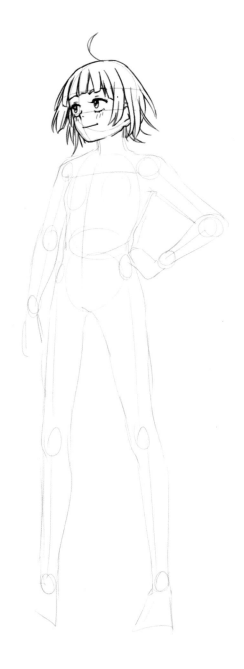

3. Put in the front of her hair. The hair to the side of her face can be blowing in the breeze slightly.

4. Draw in the rest of her hair. Give her a little feather of hair on the top of her head.

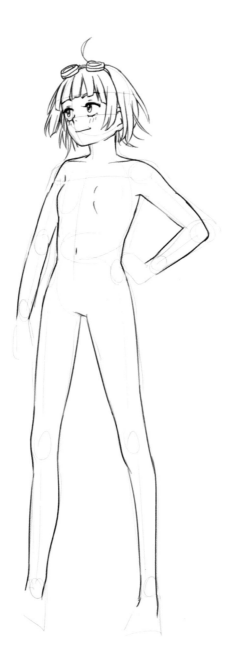

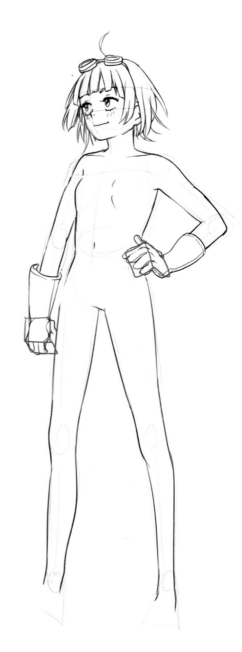

5. Outline her body. With a few little loops on the top of her head, draw in her goggles.

6. Use curved rectangles to draw in her hands. Draw gloves going up her forearms.

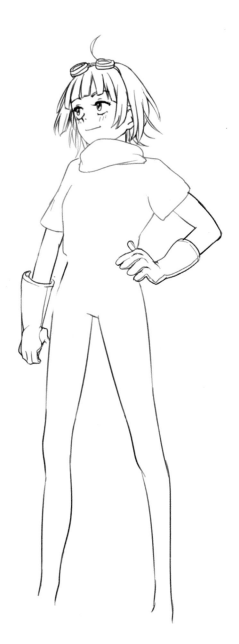

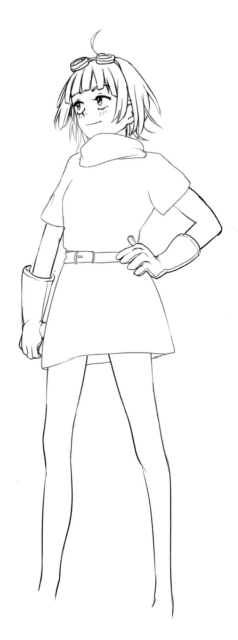

7. Start on her clothes. Give her a thick scarf around her neck.

8. Put in a skirt and belt. The skirt should go out a little past her hands.

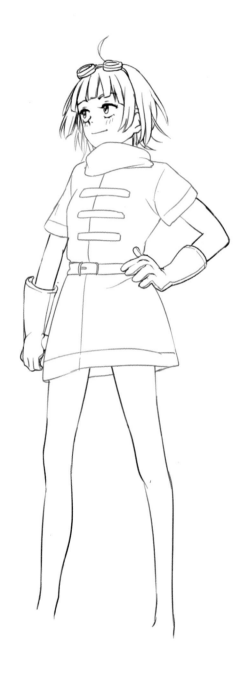

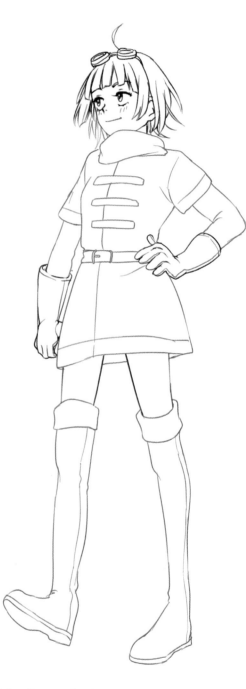

9. Add some depth to her dress.

10. Draw in long boots that go up over her knees.

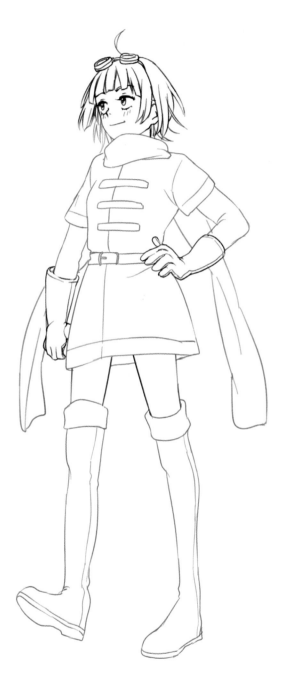

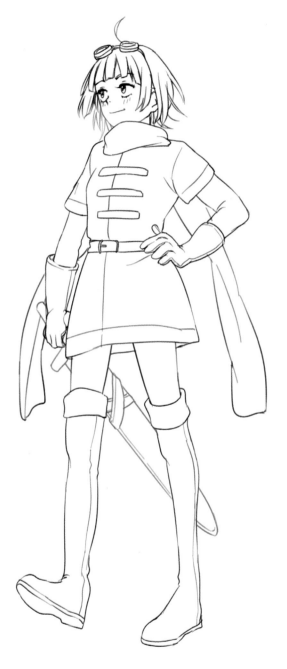

11. Finish the scarf out back behind her.

12. Draw in her sword.

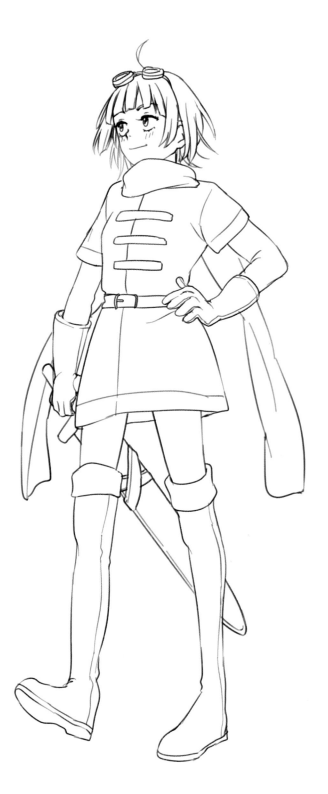

Walking

You've drawn a lot of characters standing, but how about characters walking? Watch how the movements work. Even with walking you can start with lines and circles. The characters will literally be making the same steps over and over. Once you get a feel for how a character will move, you can have them walk all over the scene. Also, keep in mind that arms tend to move as people walk.

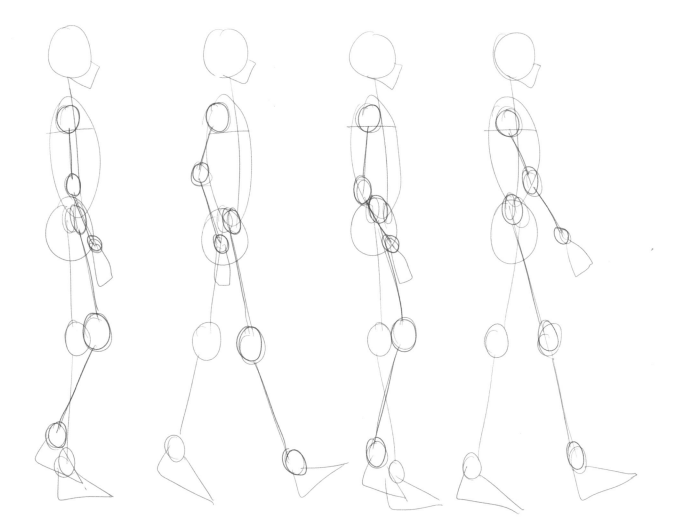

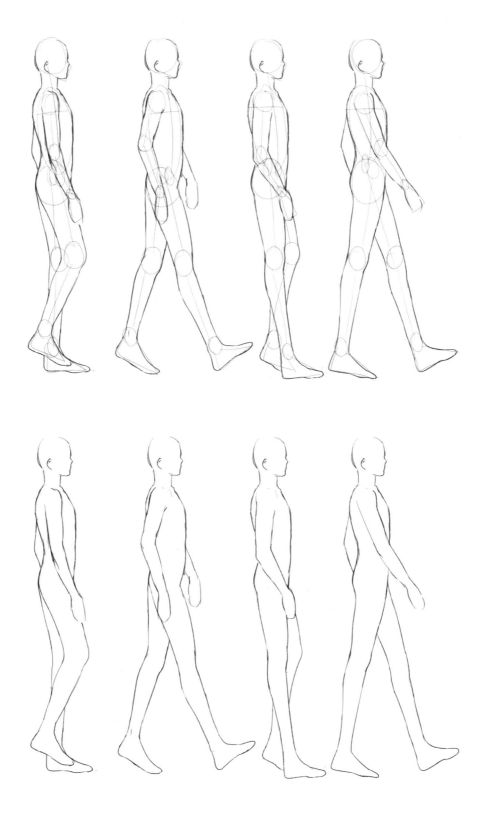

Running

As with walking, you can use lines and circles to make the characters run. But the feet should be farther apart and up in the air to show that the character is moving a lot faster. Arms can get especially aggressive in their movements while a person is running. People will also tend to lean forward when they run.

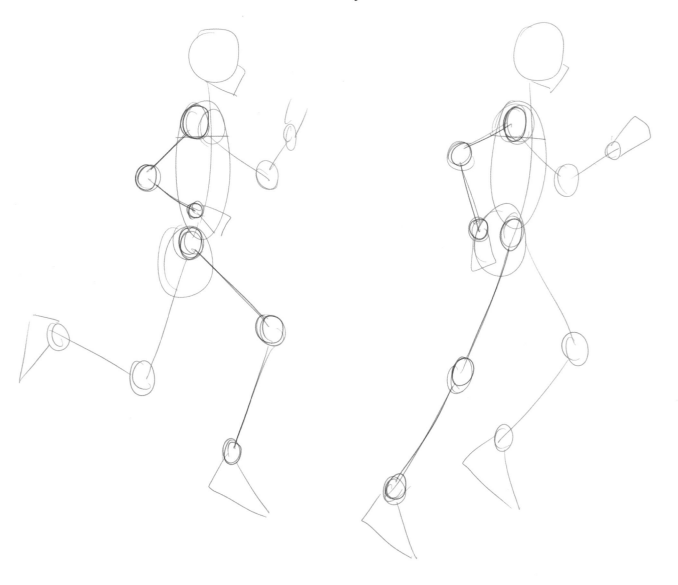

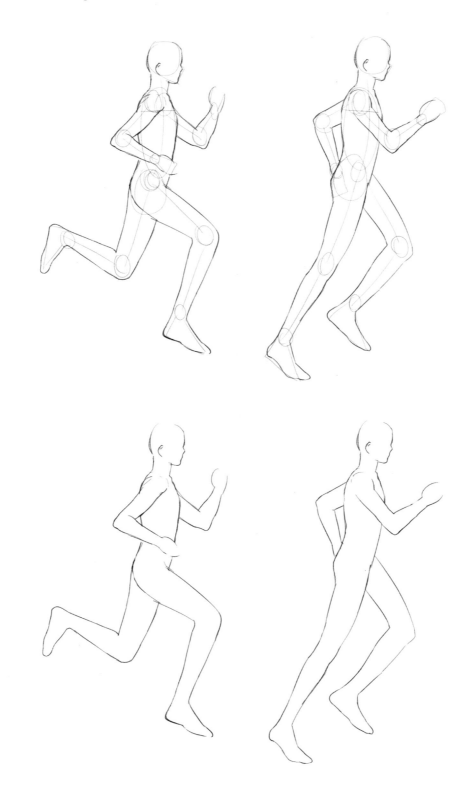

Kissing

Many manga involve kissing scenes, but they can feel pretty intimidating to draw. Watch how starting out with two circles and just doing a few steps can get you an easy and accurate kissing scene.

1. Start with two circles touching.

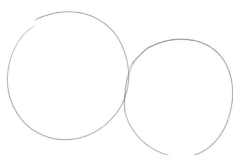

2. Draw lines in the middle of the circles to guide you.

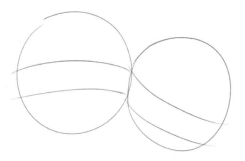

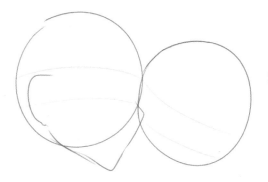

3. Draw a shape that looks like a partial square (remember at the beginning?) to guide you with the facial features. Draw in the ear.

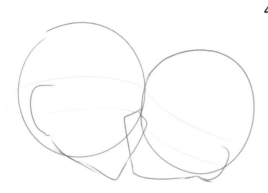

4. Draw in a squarish shape
 and ear for the other person.
 The squares will overlap.

5. Put in a little curve for where
 their mouths are touching.

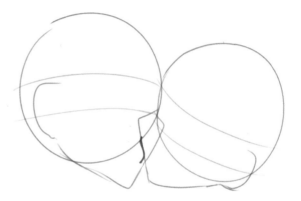

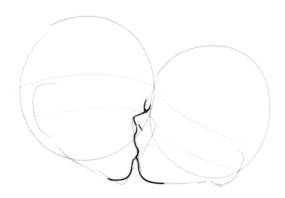

6. Start to draw in their faces around the
 mouths. Because the girl is leaning
 toward us, you will see more of her face.

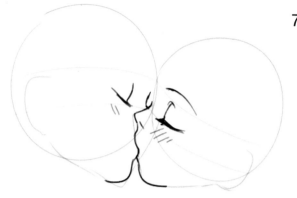

7. Put in eyes and blush marks. Remember to use the lines in the circles to guide you for placement.

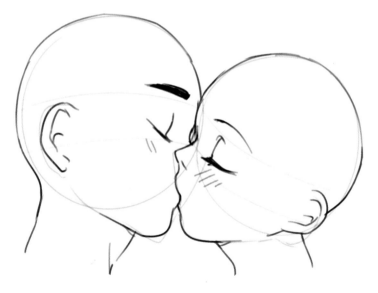

8. Add more details to the ears and draw in their eyebrows. Now that the shape is there, you can put in hair, clothing and bodies.

Hugging

Once you get a feel for drawing people, you can also apply these talents to showing people hug. And lots of manga incorporate relationships, so if you want to show two significant others hugging, this is how it's done.

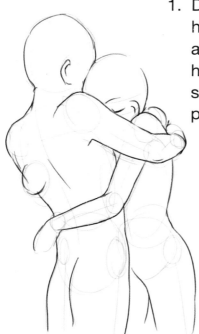

1. Draw in the basic form of people. Watch how she has one hand just peeking around from his side. Her other arm is around him. She's tucked into him. Because of how he has his arm looped around her, his right forearm will be shorter than the top part of his arm. His other hand is just peeking around her.

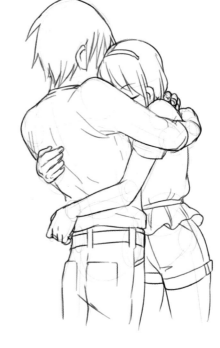

2. Once you have the basics done, you can fill in the rest of their features.

Sports

Sports can play an important role in manga. Let's take a look at how to draw some athletes in the midst of the game.

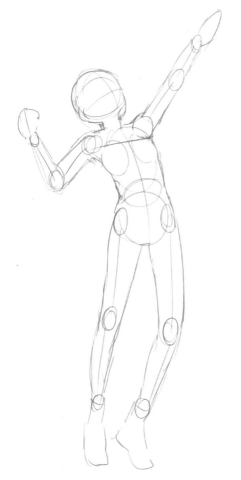

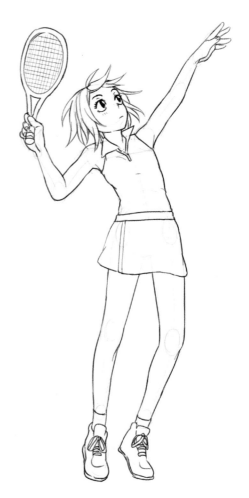

1. Draw the outline of the body. Figures can't be stiff if they're playing sports. Sometimes watching real athletes can help you with poses. She's really throwing her body into this.

2. Once you get the basic shape down, fill in the details.

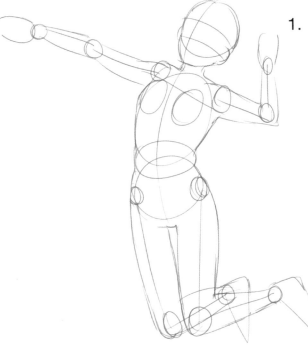

1. Watch the movement of her arms and legs. Her chest is pushed forward as she moves.

2. Fill in the details. The padding on her knees is a nice detail to show she's an athlete.

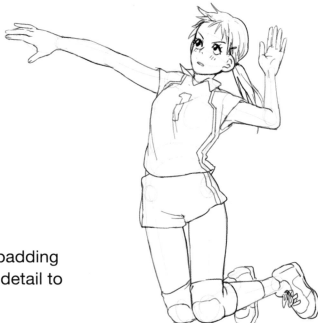

1. Notice how his whole body is moving. His legs have to also move as he swings. Because the bat is angled away, it's smaller. His face is partially covered by his shoulder

2. Fill in the details. Be aware of his small eye and the creases in his clothing that show his movement.

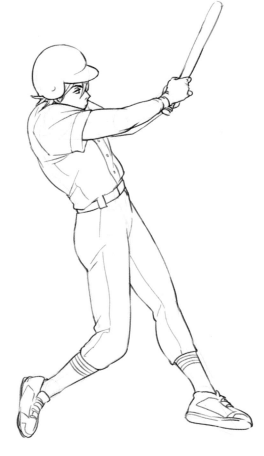

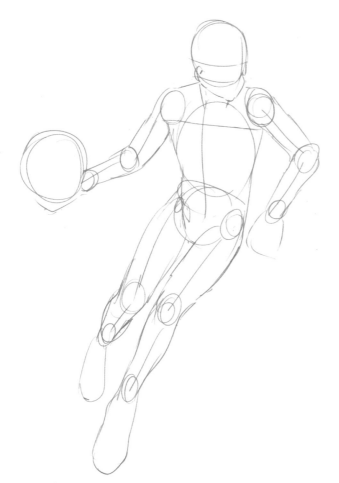

1. Due to the way he's running, his right leg (your left) will be behind him and smaller. Look at the proportions and how flexible he is.

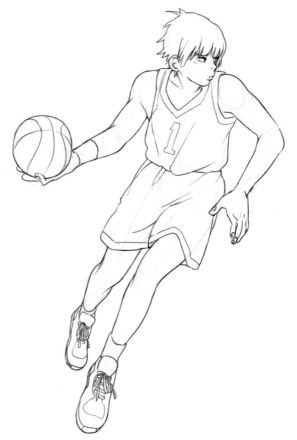

2. Fill in the details. Pay attention to how his hand is around the ball—you can see parts of three fingers and he has the ball balanced over his palm.

Conclusion

In this manga book we started with faces, went through some popular character types, and showed how to get them moving for acts like running and kissing. A love of manga is what brought this book together, plus a desire to share the layout for how to bring your own manga characters to life. If you only see the finished manga art, attempting to draw it can be intimidating, which is why we decided to really break down the steps and take away some of the mystery of how manga characters are drawn.

This book is supposed to be a stepping stone. Armed with these basics, you can continue on with your own manga and style. Practice and experiment a lot. If your drawings don't look exactly like the ones in the book at first, don't be discouraged. The artist herself learned to draw through manga books, and it took years of practice. Practicing and experimenting—especially if you can do it every day—is key. Drawing something every day will help develop your skills and your ideas. Sometimes when you're playing around and experimenting you'll come up with something great.

Keep in mind, too, that manga doesn't have to have rigid rules. You can switch up how these characters look. The sky's the limit for your imagination in manga. So keep drawing, keep experimenting, and keep loving manga!